A–Z

OF

BLACKPOOL

PLACES - PEOPLE - HISTORY

Allan W. Wood & Chris Bottomley

AMBERLEY

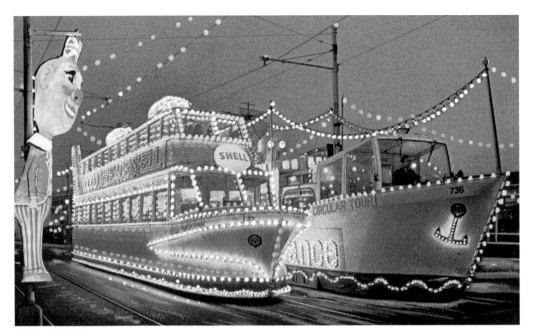

Illumination trams.

We would like to dedicate this book to Michelle and Norma, with special thanks also to Tony Sharkey and Ted Lightbown for their assistance.

First published 2018

Amberley Publishing
The Hill, Stroud, Gloucestershire, GL5 4EP
www.amberley-books.com

Copyright © Allan W. Wood and
Chris Bottomley, 2018

The right of Allan W. Wood and Chris Bottomley
to be identified as the Authors of this work
has been asserted in accordance with the
Copyrights, Designs and Patents Act 1988.

ISBN 978 1 4456 6862 8 (print)
ISBN 978 1 4456 6863 5 (ebook)

British Library Cataloguing in Publication Data.
A catalogue record for this book is available
from the British Library.

Origination by Amberley Publishing.
Printed in Great Britain.

Contents

Introduction

The words 'Blackpool A to Z' would look good in a multicoloured stick of rock, on a banner flying behind a small aeroplane or on an Illuminations tableau. An A to Z is, by necessity, a collection of miscellaneous subjects and we have tried to include the most well-known places, people and history of Blackpool, as well as a few lesser-known subjects. The book does not set out to be (and cannot be) definitive, but we hope we have captured the heart of what makes Blackpool a special place. In respect of places, Blackpool has made progress in identifying its historic buildings and protecting them. The town refuses to stand still, as demonstrated by the redevelopment of the Promenade, the tramway system, the new tramway extensions that are underway, the town centre, Talbot Gateway and the demolition of Queenstown flats to name a few. In respect of people, Blackpool's past was dominated by male figures from the time of Dr W. H. Cocker and John Bickerstaffe and has changed little in the people it has produced or who are synonymous with the town in the modern era. In respect of history, Blackpool is a relatively young town, built upon its natural assets, the change in social freedoms of the nineteenth and twentieth centuries and the entrepreneurship of those who saw its early potential. It has always been dependent upon tourism and remains a unique and vibrant place with a diverse range of attractions with the goal of remaining the UK's No. 1 holiday resort. If there were a national A to Z book, 'B' would certainly be Blackpool.

Looking north from the Tower.

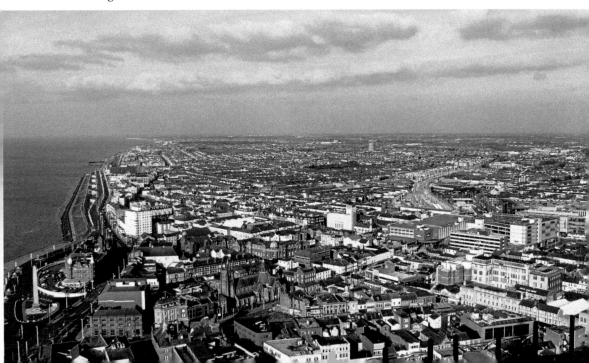

A

Armfield, Jimmy, CBE DL

Born in Denton, Manchester, on Saturday 21 September 1935, Jimmy moved to Blackpool, age seven, with his family during the Second World War. He went to Revoe School and later attended Arnold School on Lytham Road. He played his first senior team game for Blackpool against Portsmouth (away) on 27 December 1954 while doing his national service. His last game was against Manchester United on 1 May 1971. He played a record 626 games for Blackpool FC. He represented England forty-three times in the period 1959–66 and was captain fifteen times. Jimmy went on to manage Bolton Wanderers in 1971 and Leeds United in 1974. He worked as a journalist from 1979 to 1991 and later became a broadcaster for Radio 5 Live. He was made a Freeman of the Borough of Blackpool in 2003. Blackpool FC's South Stand is named after him and there is a bronze statue of him outside the ground, erected on 1 May 2011. Jimmy passed away on 22 January 2018.

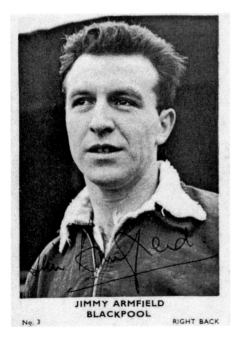

Jimmy Armfield, CBE DL.

Abattoir

The abattoir was at the very top of Abattoir Road (now Coopers Way), off Talbot Road, on land adjacent to the railway lines. The abattoir was founded in the early 1900s by John Cocker and over the years was run by his family, the Laycocks, and later R. P. Winders. After setbacks caused by BSE in 1992–93 and foot and mouth disease in 2001, the Blackpool Abattoir Co. went into receivership in August 2001, and the business was bought by Penrith Farmers and Kidds in November 2001 for just over £1 million. The new business (North West Food Products) closed in June 2003 and the buildings were demolished in 2004–05 and houses built in around 2008.

Abingdon Street Market and St John's Market

The property on Abingdon Street that now houses the market was built in 1862 and was first used as a police station, a courthouse, offices and three dwelling houses. It was later bought by T. H. Smith, a builder, to enlarge his premises and he added a storey to the building and the mock-Tudor frontage. The building was subsequently used as a car showroom by Jackson Brothers in the early 1900s. It became the Abingdon Street Market

Abingdon Street Market.

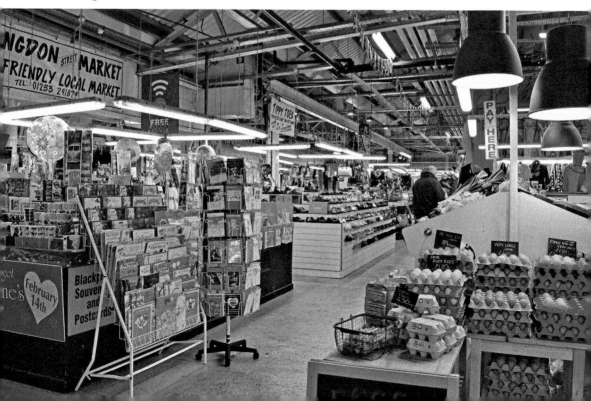

in 1928 when the main hall was built with its Belfast truss roof. The frontage of the market was refurbished in 2012 with funding from the Townscape Heritage initiative and the Heritage Lottery Fund. The market has a floor area of 13,000 square feet with over seventy stalls and sells everything from fresh food to birthday cards, as the image shows. The first St John's Market opened in February 1844 on Market Street where the Municipal Building is now. It closed in 1893. The market moved to a site on the corner of Corporation Street and West Street and was demolished in 1939. The market at the back of the bus station on Deansgate was built in 1938 and took the St John's Market name in 1939. At its height it had sixty-three stalls but closed in around 2000 and was demolished in 2006. It is now an open-air car park.

Airport (Squires Gate)

In 1909, having been inspired by the world's first public air display at Rheims in France, Lord Northcliffe wrote to Blackpool Corporation suggesting they put on an air display. This resulted in the first officially recognised (UK) public aviation meeting, held at Squires Gate from 18 to 23 October 1909, with some 200,000 spectators said to have attended. A week-long 'Flying Carnival' aviation meeting was held in 1910. In 1911–14 the Squires Gate site was developed as Clifton Park Racecourse, and during the First World War the racecourse buildings and land were used for a military convalescent home until 1924. The aerodrome was requisitioned by the Air Ministry in 1938 and three tarmac runways laid in 1940. During the period 1941 to 1945, Vickers Co. produced 3,841 Wellington Bombers at Squires Gate. Between 1946 and 1962 the airport was in government control before being taken over by the Corporation. In 2004 the airport was purchased by MAR Properties Ltd, who spent £2 million refurbishing the passenger terminal. In May 2008, Balfour Beatty bought the airport from the council, which took a 5 per cent share, but in August 2014 it was announced that the airport was for sale. After failing to find a buyer the airport closed with debts of £34 million and the loss of 100 jobs. The site became an enterprise zone in 2015 with plans to create 5,000 jobs. In 2016, the 'International' Terminal building was demolished

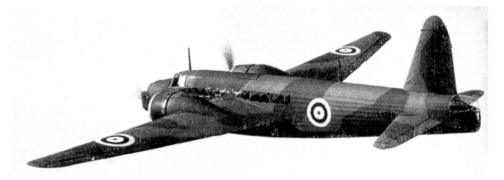

Vickers Wellington bomber.

to make way for Blackpool and the Fylde College's Lancashire Energy HQ. The airport was repurchased in 2017 by Blackpool Council and is now a base for the North West Air Ambulance, flying schools and helicopter flights to the oil and gas platforms in Liverpool and Morecambe Bays.

Alhambra (later The Palace)

The four-storey Alhambra was built in 1897–99 on what had been the site of the Prince of Wales Theatre and Baths, which before that had been a row of terraced houses named Hygiene Terrace. The Alhambra opened in 1899 and contained a 3,000-seat theatre, 3,000-capacity ballroom, 2,000-seat circus, roof garden and large central entrance hall leading to the restaurants. It closed on 22 November 1902 due to financial difficulties and was purchased by the Blackpool Tower Co., who renamed it The Palace. It reopened on 4 July 1904 and was marketed as 'The Peoples Popular Palace of Pleasure'. The interior was redesigned by Frank Matcham in the Italian Renaissance style. It contained one of the UK's earliest moving staircases, installed in 1901, and in 1911 a cinema was added. In 1914 an underground passage was added to link it with the Tower. It closed in 1961 to make way for a Lewis's department store, which itself closed on 9 January 1993. The building was later remodelled and became a Woolworths store.

Alhambra (later The Palace).

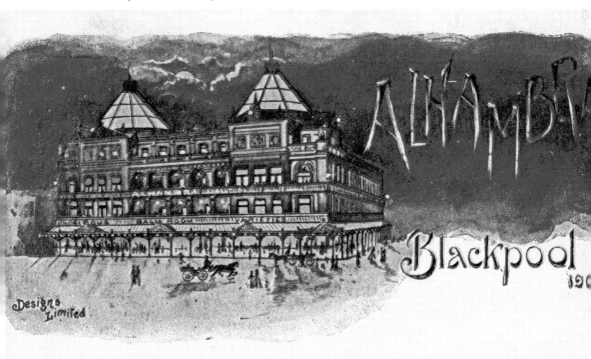

Big Wheel – The Great Wheel

The Big Wheel opened on 22 August 1896, on the bowling green plot at the corner of Coronation Street and Adelaide Street. The Big Wheel had thirty carriages each capable of holding thirty passengers and was 220 feet in diameter with an axle 41 feet long, said to then be the largest axle in Europe. The wheel was built to compete with Blackpool Tower but the ride was not a success and the Blackpool Gigantic Wheel Co. Ltd went into voluntary liquidation on 18 January 1916. The Big Wheel was bought by the Winter Gardens and Pavilion Co. Ltd and continued to operate. When the Tower Co. took over the Winter Gardens in 1928 they decided to demolish the Big Wheel and the last ride was on 30 October 1928. The Big Wheel was dismantled in 1929 and the carriages sold off. The site was subsequently transformed into the Olympia, which opened in 1930.

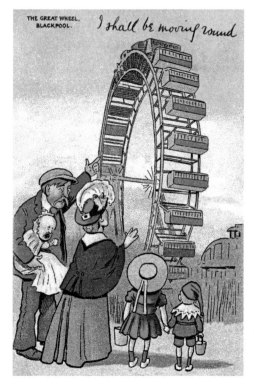

The Great Wheel.

Bailey's Hotel, Butlin's Metropole

The hotel was built by Layton farmer Lawrence Bailey and was originally named Bailey's Hotel when it opened in around 1784. It then had thirty-four bedrooms and is one of the oldest hotels in Blackpool. It remains the only hotel on the seaward side of the tram tracks. Over the years the hotel has undergone several renovations and extensions and had several names. It was bought by Metropole Hotel Ltd in 1893 and was requisitioned by the government between 1939 and 1947. Billy Butlin bought the hotel in 1955 and sold his hotel chain to Grand Hotels in 1998, after which it was renamed as Grand Metropole Hotel. In 2004 it was sold to Britannia Hotels.

Billy Smith

Billy Smith owned Bridge End Farm at Carleton where he had a vile-smelling bone factory and he operated Blackpool's first bus service in 1920. He was best known for his 'Aladdin's Cave' and Army Surplus items at his junkyard in Talbot Road, next to what was then the railway goods and coal yard. He also dealt in scrap metal and recyclable textiles and local children would collect lead, old batteries and old clothing and 'weigh it in' for pocket money. Billy's yard gave rise to the local saying 'It's like Billy Smith's Junk Yard' when referring to an untidy situation. The Talbot Road yard closed in the 1970s and the area, now Spencer Court, was developed for social housing by Blackpool Borough Council.

Bispham Church, Village and Gala

Bispham Parish Church (also known as All Hallows Church) is a Church of England church on All Hallows Road, Bispham. It is known as the Mother Church of Blackpool and until

Below left: Bispham Church. *Below right*: Bispham Gala.

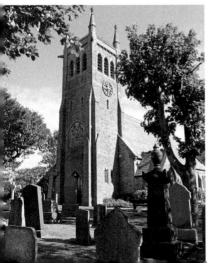

1821 was the only place of worship in Blackpool. It is the third church to have been built on the site, the first being built during the reign of Richard I (1189–99). The present church, seen in the photograph, was built in 1883 and is a Grade II-listed building. The churchyard contains war graves and the graves of sailors shipwrecked on the Fylde coast. The churchyard also contains a sundial that is Grade II listed. The area of Bispham has been inhabited for millennia and 'Biscopham' is mentioned in the Domesday Book (of 1086). It was a village in its own right until being incorporated into Blackpool on 1 April 1918. While the shopping area now spreads up Red Bank Road to Queen's Promenade, the old village was east of what is now the roundabout at Devonshire Road. Many of the houses in the old village existed until the 1960s, before being devastated by commercial development. Bispham with Norbreck Gala is held annually in July on the gala field off All Saints Road, and each year one of the churches in the Bispham area nominates a Gala Queen. In 2017, the gala's 122nd year, the Gala Queen was Queen Tia from St Bernadette's Church.

Blackpool Football Club

Blackpool Football Club was founded on 26 July 1887 from the nucleus of the St John's Football Club and played at Raikes Hall Gardens (and also for a period at the Athletic Ground, near the present cricket club). The club merged with South Shore Football Club on 21 December 1899 and moved to the new ground at Bloomfield Road in 1901. They have had a 'roller coaster' existence, winning the 1953 'Matthews' FA Cup final, finishing runners-up in the First Division (1955/56 season), finishing 21st in the Fourth Division in 1983 and being promoted to the Premier League in 2010, but demoted in 2011. In the 2017/18 season they are in English Football League One.

Blackpool Football Club.

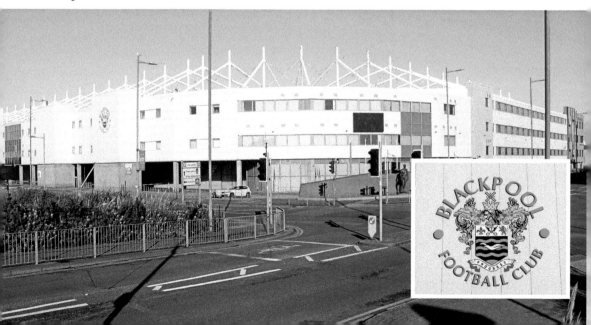

C

Comedy Carpet

Akin to the Hollywood Walk of Fame but bigger and better, in typical Blackpool style, the Comedy Carpet is sited on the Festival Headland immediately in front of Blackpool Tower. The typographical artwork was commissioned by Blackpool Council and funded by CABE (Commission for Architecture and the Built Environment) at a cost of £2.6 million and was created by artist Gordon Young and designed in collaboration with Why Not Associates. The Comedy Carpet covers an area of some 2,200 m^2, containing over 160,000 granite letters embedded into concrete, celebrating comedy in a written and visual form with the jokes, songs and catchphrases of over a thousand comedians and comedy writers.

Comedy Carpet.

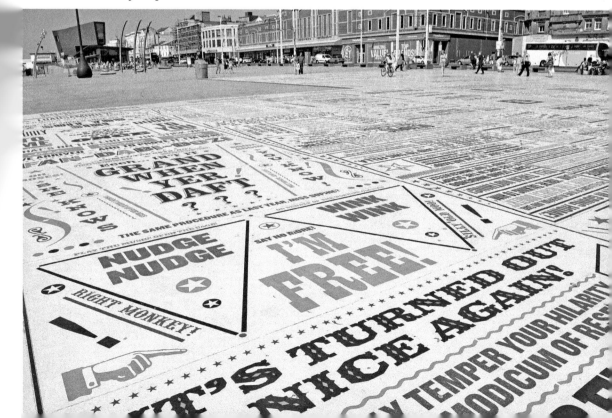

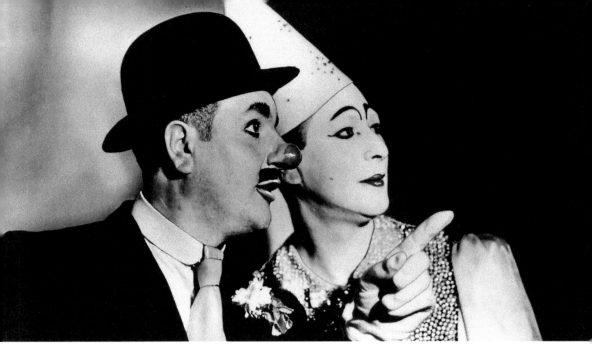

Charlie Cairoli.

Cairoli, Charlie

Charlie was born in Milan, Italy, on 15 February 1910 and began his circus career at the age of seven. He met his wife (Violetta) in 1934 at the Cirque Medrano in Montmartre and they had three children: Regina, Mary Diana and Charlie. Charlie's first appearance at the Tower Circus was in 1939. His trademark costume was his red nose and Charlie Chaplin-style bowler hat, eyebrows and moustache. In the next forty years his name became synonymous with the Tower and he appeared at the Royal Variety Performance on 13 April 1955 at the Blackpool Opera House. He was the subject of an episode of *This is Your Life* in 1970. He retired in 1979 and passed away in his sleep at his Warley Road home on 17 February 1980 aged seventy. A statue of Charlie (by sculptor Brian Nicholson) was unveiled in the Rose Gardens at Stanley Park on 21 April 2013 and relocated shortly after to the Blackpool Tower building. The photograph is of Charlie with his white-faced clown assistant Paul Freeman.

Carmen, George, QC

George Alfred Carman, QC, was born in Blackpool on 6 October 1929 and attended St Joseph's College on Newton Drive. He later attended a seminary in Upholland. After national service he studied jurisprudence at Balliol College, Oxford, and was called to the Bar in 1953 (Lincoln's Inn). He became the most famous English barrister of the 1980s and '90s when he represented Jeremy Thorpe (Liberal leader charged with murder), Peter Adamson (Coronation Street star) and Ken Dodd, to name a few. George was married three times and had one son (Dominic). George died in Merton, London, on 2 January 2001.

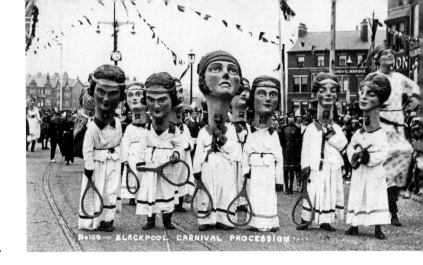

Blackpool Carnival.

Carnivals, 1923 and 1924

Blackpool held two hugely successful carnivals on 9–16 June 1923 and 11–24 June 1924 with long processions along the Promenade and over 100,000 visitors attending. Unfortunately it appears that drunkenness, rowdyism and uncouth behaviour in 1924 put an end to the annual event. The carnival was revived on Sunday 23 July 2017 with a parade from Central to South Pier.

Central Library and Grundy Art Gallery

1909 saw the commencement of the building of Blackpool Central Library and adjoining Grundy Art Gallery, which were completed in 1911. The building, in red brick with stone dressings, was designed in the Edwardian Baroque style by Cullen, Lochhead and Brown and was designated a Grade II-listed building in October 1983. The library closed for a £3-million renovation in August 2010 and reopened 26 September 2011, one month before its centenary on 26 October 2011.

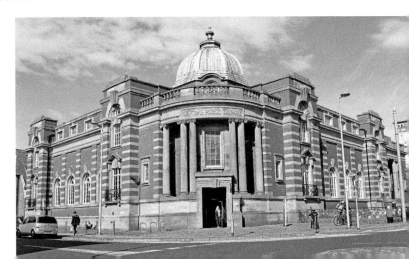

Central Library and Grundy Art Gallery.

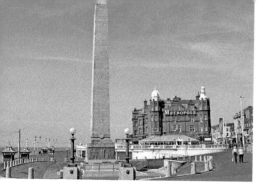

Cenotaph, Princess Parade.

Cenotaph, Princess Parade

A 'cenotaph' is a monument to persons whose bodies lie elsewhere, reflecting the fact that not all bodies are repatriated from war zones. Blackpool's war memorial and cenotaph was unveiled on Armistice Day, 11 November 1923, and stands on Princess Parade (opened by HRH Princess Louise on 2 May 1912) between North Pier and the Metropole Hotel. It comprises a 100-feet-high white granite obelisk on a square pedestal, designed by Ernest Prestwich with bronze plaques sculpted by Gilbert Ledward and is Grade II* listed. The sculptures are particularly unusual for the depiction of a fallen German soldier. It underwent restoration in 2007–08.

Central Station

Central station opened as Hounds Hill station on 6 April 1863 at the end of the Blackpool & Lytham Railway line and was renamed Central station in 1878. It was given a new façade in 1899 and enlarged in 1901 (it had had fourteen platforms at the time). In 1901, it was said to be one of the world's busiest railway stations. During the Second World War, on 27 August 1941, a tragic mid-air collision between two aircraft resulted in a large amount of the debris falling on the station causing twelve deaths. The photograph shows the inside of the station, which closed on 2 November 1964 as part of the Beeching recommendations. Part of the building was used as a bingo hall until 1973, after which time the station was demolished, although the toilet block survived until 2009. Coral Island amusement arcade now stands on the site of the former ticket hall and there are currently plans to redevelop the old station area between New Bonny Street and Chapel Street. This will include the demolition of the police building after they move to the new 'Fylde HQ' on Clifton Road later in 2018.

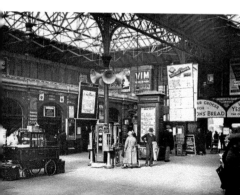

Central station.

Cinemas

Blackpool has had many cinemas over the years and now only the (new) Odeon (opened in 1998) on Rigby Road and the reopened (29 July 2016) Regent Cinema (opens on Friday nights) on Church Street serve the town. A new cinema complex is planned for the town centre. The cinemas of the past are listed below: Dominion (Red Bank Road, 1938–72); Imperial (Dickson Road, 1913–61); Princess (opposite the Metropole, 1912–81); Odeon (Dickson Road, 1939–98); ABC (Church Street, 1910–98), as the Empire Theatre (originally), later the Hippodrome, ABC and Cannon (MGM); Clifton Palace Cinema (on Church Street opposite Marks & Spencer, originally built as the Blackpool Liberal Club, 1910–49), later the Tatler News Theatre (1950–54); Tivoli (Yates's building) originally with Lumiere's Cinematograph in 1897 and later, intermittently from *c.* 1909 to 1982, Palace Picture Pavilion (in the Palace, 1911–58); Jubilee Theatre (top floor of the Co-op Emporium, 1938–88); Ritz (next to the Huntsman on the Promenade near Chapel Street, originally Central Beach Cinema, later the Trocadero Cinema – intermittently between 1913–71); King Edward Cinema (formerly Central Picture Theatre) on Central Drive (1913–72); Royal Pavilion Theatre (Rigby Road, 1909 to *c.* 1983), also previously named the Futurist in 1929, the Plaza in 1939, and the New Alexander Cinema, in 1948; Rendezvous (Bond Street, 1925–73); Palladium (Waterloo Road, 1928–76), Waterloo on Waterloo Road; Empire (Hawes Side Lane, Marton, 1929–59) and Oxford (Oxford Square, 1938–60).

Cocker, Dr W. H.

Dr William Henry Cocker was born on 9 December 1836 in a house on Hygiene Terrace, on the Promenade opposite where the new Wedding Chapel is now. His father was Dr John Cocker, who had married Jane Banks (daughter of Henry Banks) in 1832 and owned Bank Hey House at the top of Victoria Street, part of which still is still within the Winter Gardens. William married Betsey Pilling of Rochdale in 1858 but they had no children. He was a major player in the development of Blackpool and in 1875 he gave up his practice as a surgeon and opened an aquarium and menagerie on land which later became the site for

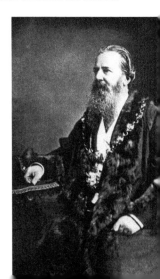

Dr W. H. Cocker, Blackpool's first mayor.

Blackpool Tower. He was Blackpool's first mayor on the town's incorporation in 1876 and first freeman of the town in 1897. He died on Good Friday, 14 April 1911, and was buried in St John's Churchyard. The Cocker Clock Tower in Stanley Park, which opened in June 1927, is a memorial to Dr W. H. Cocker.

Cooke, Alistair, KBE

A journalist, TV presenter and broadcaster, Alistair Cooke was born on 20 November 1908 in Manchester and moved to Vance Road, Blackpool, with his family in April 1917 when he was eight. They later lived in Ormond Avenue, near Gynn Square. He attended Blackpool Municipal Secondary School, Raikes Parade (later renamed Blackpool Grammar School), in 1920 and later Jesus College, Cambridge, where he read English. He emigrated to the United States in 1937 and was famous for his weekly radio programme, originally named *American Letter*, which first broadcasted on 24 March 1946. It ran for fifty-eight years (2,869 installments) until March 2004, changing its name in 1950 to *Letter from America*. Cooke died on 30 March 2004.

Co-op Emporium (Coronation Street)

The much-loved Co-op Emporium, with its pillars on the Coronation Street frontage, was built by the Blackpool Co-operative Society in 1938. As well as 'superstore'-style shopping with everything under one roof, the Co-op offered its members dividends, death benefit insurance calculated according to purchases, a Christmas (savings) club with stamps collected through the year, 'Mutuality Club' and hire purchase terms. 'Millinery and Gowns' were on the first floor of the Emporium as was the Ladies' hairdressing salon. There was also a café/restaurant and the Jubilee Theatre on the top floor, with seating for approximately 800 people. The store was demolished in 1988 and the site became a car park for many years until it was developed as part of the Hounds Hill Centre extension. This opened in September 2008 and is now occupied by a Debenhams department store and a New Look store.

Co-op Emporium (Coronation Street).

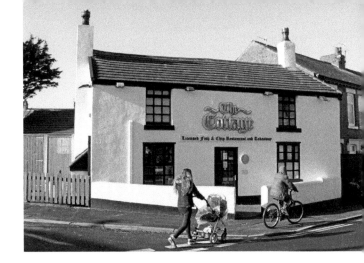

The Cottage.

Cottage, The

One thing that Blackpool is not short of is fish and chip shops. The most famous of these must surely be The Cottage chip shop at No. 31 Newhouse Road, Marton. The premises were built in 1856 and it has been a chip shop since 1920. From Status Quo to the Prime Minister John Major, The Cottage has been popular with celebrities and politicians. Rick Stein in his *Seafood Lovers' Guide* judged The Cottage as Blackpool's best chip shop.

Cricket Club

Blackpool Cricket Club is on Barlow Crescent, off West Park Drive, within Stanley Park. While a joint Blackpool Cricket and Football Club was founded in 1879, the sports split and Blackpool Cricket Club, one of the oldest in the North West, was formed in 1888. They originally played at Raikes Hall Pleasure Gardens, moving to Whitegate Park in 1893. The ground was renamed Stanley Park in 1925 because it then fell within the boundary of the new park. The 1st and 2nd XI play in the ECB Northern Premier League. Its 3rd XI turn out in the Palace Shield and its 4th XI play in the Fylde League. The club also has ladies and junior teams.

Blackpool Cricket Club.

Dance Festival

The Blackpool Dance Festival (the largest of Blackpool's five dance festivals) is held every May in the Empress Ballroom at the Winter Gardens and incorporates the British Open championship. The festival covers ballroom and Latin American dancing. The competition was first held in 1920 and is now marketed as the world's first and foremost festival of dance. In 2017 there were 2,970 entries from sixty-one countries.

Derby Baths

The yellow faience-clad Derby Baths and its Olympic-sized pool opened in July 1939 on the south side of Warley Road, at the Promenade. It regularly hosted UK and internationally televised swimming events and diving competitions in the 1950s and '60s. There was a 10-metre-high diving board at the south end, a learner pool in the basement and a sun terrace on the south facing part of the roof. A visit to the café at the north-east end of the baths was always a must after swimming, whether to have an oxtail soup, Bovril or hot chocolate. Despite the addition of the separate sauna building in 1965 and later (1987) the 'Splashland' tubular water slides, by the late 1980s it was failing to compete with attractions such as the Sandcastle Water Park. The baths closed in 1987 due to the poor condition of its structural steelwork and the (above ground) building was demolished in 1990. The site remains undeveloped.

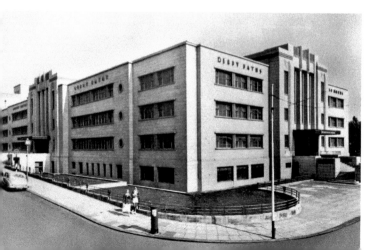

Derby Baths.

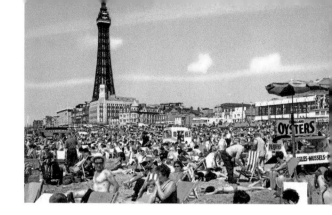

Deckchairs.

Deckchairs

From around 1914, deckchairs on the beach, like rock, candy floss, ice cream and fish and chips, were part of the normal and expected vista on Blackpool promenade. At its peak between 1958 and 1960 Blackpool Council is said to have received some £6 million in revenue from deckchair hire. However, changes in visitor numbers and expectations led to the demise of the facility and in 2014, after being mothballed for three years, Blackpool Council sold its 1970s stock of 6,000 deckchairs to a company that hires them to weddings, festivals, concerts and other events.

Dixon, Reginald, MBE, ARCM

Reginald Herbert Dixon was born in Ecclesall, Sheffield, on 16 October 1904. He began playing the organ and piano at the age of two and gave up school at the age of thirteen to continue his music studies. He worked as a pianist and organist at picture houses and in

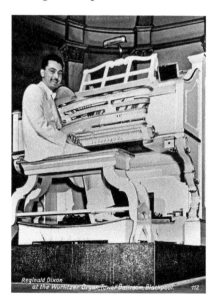

Reginald Dixon.

1930 auditioned to become the organist on a 2/10 Wurlitzer at Blackpool Tower Ballroom. He was the organist at the Tower from March 1930 until March 1970. During his career he gave regular radio broadcasts sometimes to audiences of over 6 million and sold more recordings than any other organist before or since. In 1955 he performed at the Royal Variety Performance in the Blackpool Opera House in front of Elizabeth II, who told him that she often listened to his radio broadcasts. In 1956 he switched on the Illuminations. Reginald was made an MBE in 1966 and retired from the Tower in 1970. He passed away on 9 May 1985.

Donkeys

Donkeys have, since Victorian times, had a long and noble link to seaside entertainment, and it is not unusual to find pre-war accounts or images of hilarious seaside visitor jinks including the riding of donkeys not just by children but by large adult visitors. Blackpool was not the first to introduce a Donkey Charter for the welfare of the animals – neighbouring Lytham St Annes adopted one in 1927 – but an appeal by the editor of the *West Lancashire Evening Gazette* in 1942 soon led to the introduction by the Corporation of the 'Regulations with Reference to Asses on the Foreshore', more commonly known as the Donkey Charter. This limited the hours of work of donkeys and gave them a day off on Fridays. It also limited rides to persons under the age of sixteen and under 8 stone in weight. Traditionally they have a name badge on the front of their bridle.

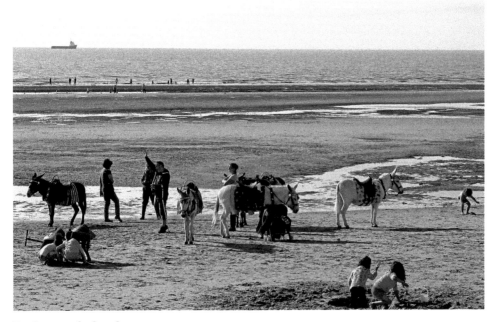

Donkeys on the beach.

Duple Coaches

H. V. Burlingham coach builders (1928–60) had their main factory on Vicarage Lane, Marton, from 1931. They built Blackpool's iconic centre entrance double-decker buses and the famous Seagull coach. The company was taken over by Duple in 1960, who became a major coach manufacturer in the post-war years. Changes in the coach industry and the import of foreign coaches brought about a downturn in the business with production of 1,000 bodies in 1976 decreasing to 500 by 1981. The struggling company was sold to the Hestair group in 1983, and in November 1988 Hestair announced the company was being taken over by a management buyout team. The Blackpool factory eventually closed in 1990 having sold the manufacturing rights to their main rival Plaxton and the Duple body designs to the Carlyle Group. Blackpool's long tradition of coach body building had ended.

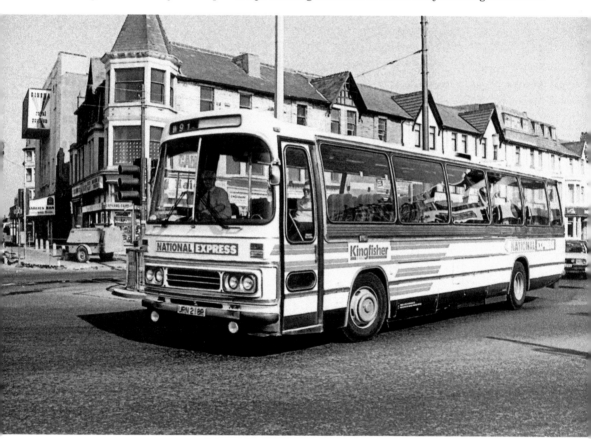

Duple coaches.

Eric and Ernie (Morecambe and Wise)

John Eric Bartholomew (14 May 1926–28 May 1984) and Ernest Wiseman (27 November 1925–21 March 1999) first appeared together in 1941 and first appeared in Blackpool in 1949 at Feldman's Theatre, although they had appeared individually in a show at the Palace Theatre in 1940. They went on to appear over 1,000 times in Blackpool, including an appearance in the 1955 Royal Variety Performance at the Opera House, by which time Blackpool had become their 'spiritual home'. Eric and Ernie's last Blackpool performance was on 23 October 1976 at the Opera House. In October 2016, the bronzed statue, seen in the photograph, was unveiled in the domed entrance of the Winter Gardens to commemorate the seventy-fifth anniversary of Eric and Ernie first appearing on stage together. The 8-foot statue of the greatest and best-loved British comic double act was created by Graham Ibbeson and depicts Eric and Ernie in a typical affectionate pose.

Below left: Eric and Ernie (Morecambe and Wise). *Below right*: Empire Pools.

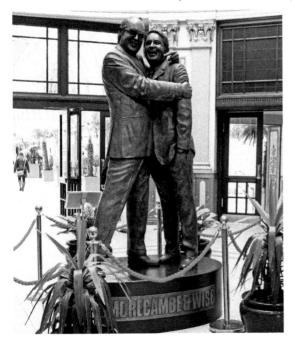

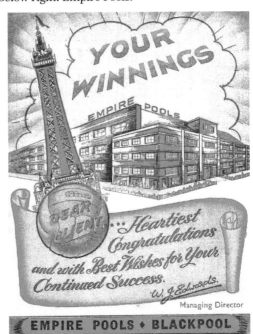

Empire Pools

Empire Pools Ltd was a Blackpool-based football pools company started in 1935 in competition with Littlewoods and Vernons. They had offices in the art deco Gazette building on Preston New Road (now the site of Dove Tree Court housing and McDonalds) and at nearby Chiswick Grove and employed 'checkers' (often students) to work on Saturday evenings and Sunday mornings checking the returned coupons for winners. The first 'all over' advert on a Blackpool tram was for Empire Pools in 1975.

Elmslie Girls' School

A house named The Elms was built on Whitegate Drive (then Whitegate Lane) for William and Sarah Powell in 1896. In 1918 it became Elmslie School, an independent girls' school. Miss Elizabeth Brodie was the headmistress from 1918 to her retirement in 1952 when Miss Laura Oldham was appointed headmistress. Miss Oldham retired in 1978 and was followed as headmistress by Miss E. M. Smithies and later Miss S. J. Woodward. The school closed on 31 August 2000 and as the photograph shows, the site has been transformed into residential use. The Elms house is retained and is now a Grade II-listed building.

Elmslie Girls' School.

FA Cup, 1953

Usually referred to as the 'Matthews Final', the 1953 FA Cup final is probably the most famous cup final as it was Stanley Matthews' third attempt at the age of thirty-eight to gain a cup-winners' medal, having lost in the 1948 final to Manchester United and again in the 1951 final to Newcastle United. To add to the drama, the 100,000 spectators watched Blackpool come from being 3-1 down against Bolton Wanderers to win 4-3 in injury time and saw Stan Mortensen score the only ever hat-trick in an FA Cup final at Wembley. The final was said to have been watched by 10 million viewers and was the first major sporting event to attract such an audience.

FA Cup, 1953.

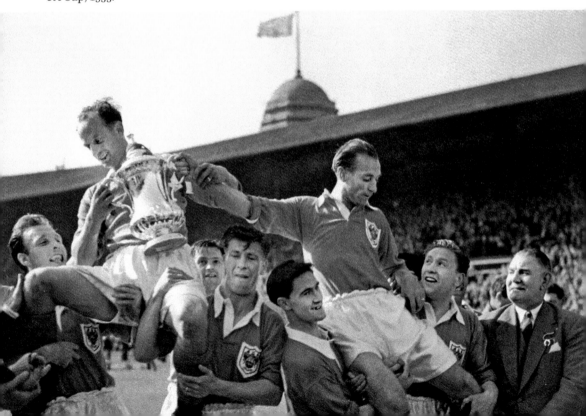

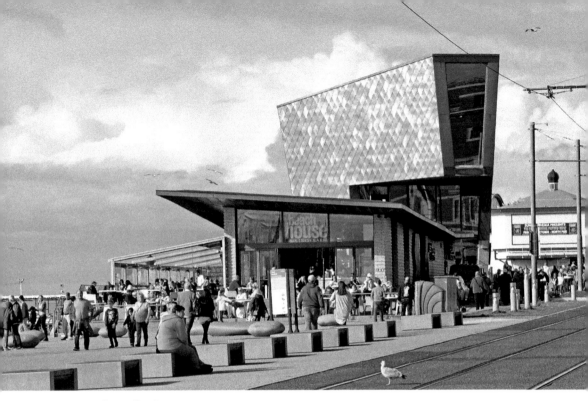

Festival Headland.

Festival Headland

The Tower Festival Headland was formed by extending the promenade an extra 60 metres seawards. It is a public space used for major outdoor events and concerts and can accommodate 20,000 people. The opening concert was performed by Sir Elton John on 16 June 2012. The site incorporates Festival House, which houses a wedding chapel, tourist information office and the Beach House Restaurant, as the photograph shows. In July 2012, Festival House was named as one of Britain's fifty best new buildings and in November 2012 the Festival Headland won the Design Excellence award in a national competition.

Fire Stations

The Blackpool Volunteer Fire Brigade was formed in 1858 and was housed in a yard behind the Tower in Hull Street. A second fire station was in the Corporation Yard in Hull Street/ Back Sefton Street in around 1876 and had horse-drawn fire engines. The foundation stone for Blackpool's fire station located on the south side of Albert Road (near South King Street) was laid on 26 October 1900 and the brigade moved there in 1901. The station formally opened on 26 October 1904 and received its first motorised engine on 13 December 1913. The Blackpool County Borough Brigade was created on 1 April 1948 pursuant to the Fire

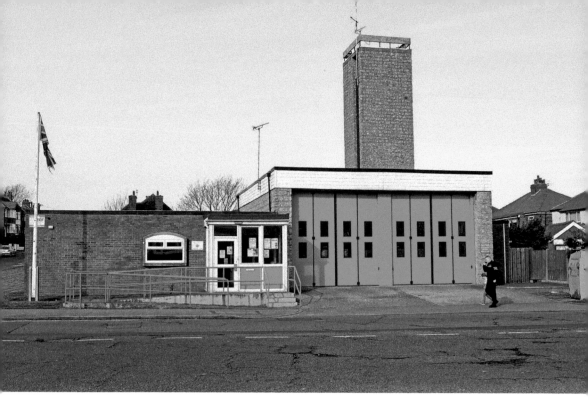

Fire station, Bispham.

Services Act 1947 and is now part of the Lancashire Fire and Rescue Service. Blackpool fire service has attended many major fires including the Blackpool Tower Ballroom fire in 1956, the RHO. Hills fire in 1967 and Yates's fire of 2009. The names of firefighters who have lost their lives in service are contained in the Firefighters Memorial Trust's Book of Remembrance. The Albert Road fire station closed in 1987. Blackpool now has three fire stations. The present central Blackpool fire station is at No. 62 Forest Gate (near Stanley Park) and was opened on 10 April 1987. A fire station has been on the Red Bank Road, Bispham, site since 1938 and the 'new' fire station, seen in the photograph, was opened on 22 July 1966. The St Annes Road fire station opened on 26 November 1973 and replaced the station on Hill Street/Lytham Road. There was also a fire station at Blackpool Airport providing airfield fire cover.

Foxhall

Around 1660 Edward Tyldesley built Fox Hall as a summer residence. The house had a chapel and priest holes. It was later used as a farmhouse and then as an inn. When R. Seed & Co. owned it in the early 1900s they boasted in advertisements that it had a harmonic room and the finest billiards in town. C&S (Catterall and Swarbricks) bought Fox Hall in February 1964 and the old building was demolished in December 1990. The current red-brick building now houses the Reflex Foxhall, a 1980s-themed bar and nightclub, which opened in July 1991.

G

Golden Mile

For Blackpudlians, the Golden Mile is that length of Promenade between Hounds Hill and Chapel Street/Central Pier. In the late 1800s the Promenade property south of Hounds Hill (then known as South Beach) was largely residential, catering for the seasonal visitors to the town. Due to a council restriction placed on traders/fortune tellers/amusements operating on Central Beach in 1897, the traders moved their stalls into the gardens/frontages of the Promenade property opposite and continued trading. Amusement arcades, sideshows, theatres, ice cream, and fish and chip stalls gradually took over all the properties along this length and the Golden Mile was born. The name is said to refer to the extent of slot machines but more probably refers to it being the place where the most money was spent by visitors. The buildings eventually became ramshackled. In the 1960s and '70s they were largely demolished and replaced with modern amusement arcades and attractions such as Star Attractions (previously Mr B.'s Golden Mile Centre and before that the Luna Park amusement arcade), the Sea Life Centre, Funland and Madame Tussauds, together with rock, candy floss and burger stalls.

Gas and Electric Lighting

The Blackpool Gas Works were built in around 1852 on land between Princess Street and Rigby Road, east of the railway lines into Central station, and provided the gas for the town's street lighting. In September 1879, Blackpool installed a form of municipal street lighting when it used Dr. Siemens' eight dynamo-electric machines powered by sixteen

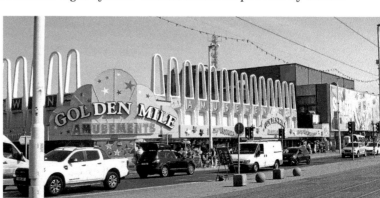

The Golden Mile.

Robey engines to power eight arc lamps on the promenade, spaced 320 yards apart. In typical Blackpool fashion, the lighting had been advertised nationally and between 70,000 and 100,000 visitors are said to have witnessed the event.

Gay Scene

Blackpool has a thriving 'Gay Scene' and is often referred to as the 'Gay Capital of the North'. It has its own gay pride week (since 2006) and the town promotes itself as a gay-friendly town. The area centred around Queen Street and Dickson Road has many pubs, clubs and bars catering for the LBGT community, including Funny Girls in the iconic Odeon building.

Gazette

Blackpool Gazette ('*The Gazette*') is an evening paper published six days a week, serving the towns and villages of the Fylde. It dates back to a group of newspapers founded in 1873 by John Grime, a printer, from a family of printers. *The Gazette* began publication in 1929 as the *West Lancashire Evening Gazette* and later the *Evening Gazette* before becoming the *Blackpool Gazette*. The chairman and editor-in-chief in the 1950s and 1960s was Sir Harold Riley Grime, the third generation of the Grimes to run the paper. Sir Harold, died on 31 August 1984, aged eighty-eight. *The Gazette*'s main offices, seen in the photograph, were built in 1934 in Victoria Street and were designed by Halstead Best. They were demolished in 1987 and replaced with shops. The offices moved to the former Telefusion offices on Cherry Tree Road and subsequently relocated to Avroe Crescent, Squires Gate. The paper is now owned by Johnston Publishing Ltd.

Below left: Blackpool Gazette office, April 1974. *Below right*: General Post Office, Abingdon Street.

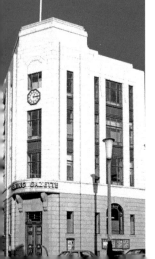
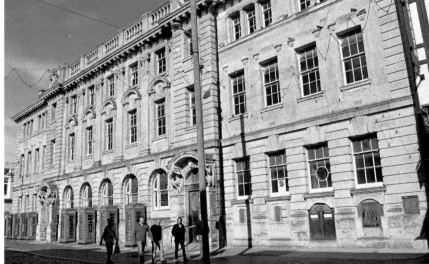

General Post Office, Abingdon Street

The three-storey GPO building (and telephone exchange) at Nos 26–30 Abingdon Street opened on 8 November 1910, and is faced with Portland stone in the Renaissance style. It is a Grade ll-listed building. The eight red K6 telephone boxes outside on Abingdon Street are also Grade II listed and were designed in 1935 by Giles Gilbert Scott. The GPO on Abingdon Street closed in 2007 with the business transferring to a new office in the basement of WHSmith on Bank Hey Street. There are now plans to transform the building into a retail complex.

Glenroyd

Blackpool's maternity hospital on Whitegate Drive was originally opened on 14 April 1906 as the Co-operative Convalescent Home. The home was requisitioned in 1946 for maternity cases. It closed and was demolished in around 1975, following the completion of the new maternity wing at Victoria Hospital. It is now the site of the Glenroyd Medical Practice and Glenroyd Care Home.

Grand Theatre

The site on the Church Street corner of what was then St Annes Street was bought by Thomas Sergenson in 1887, who initially erected a wooden building and presented the Grand Circus in the summer months for five years. In 1893, Sergenson engaged Frank

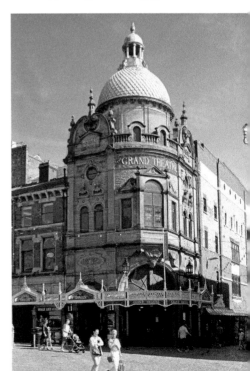

Grand Theatre.

Matcham to design the Grand Theatre, which was completed and opened on 23 July 1894 at a cost of £20,000. The theatre was sold to the Tower Company in 1909 for £47,500 and was owned by them until 1968 when EMI purchased the Tower. The Grand became a listed building in 1971 but closed in 1972 due to falling revenues. It reopened as a bingo hall in 1977 and in 1981 the theatre was bought by the Grand Theatre Trust and some £3 million of renovation and improvement work was undertaken. It was officially reopened by Prince Charles on the 23 March 1981 with a Royal Variety Performance. The Grand Theatre is supported by the Friends of the Grand, which was formed in 1973.

Grange Park

The area east of Little Layton was farmland with scattered clay pits up until the late 1940s when construction of the Grange Park housing estate, by Blackpool Corporation, started. Grange Park has two primary schools: Boundary Primary School on Dinmore Avenue and Christ the King Catholic Academy on Rodwell Walk. Boundary Primary School, which opened in September 2003, was built next door to the old Grange Park Junior School, which was demolished in 2013. The Dinmore Hotel (although it was never a hotel) was originally (*c.* 1960) a Magee Marshalls pub but later changed to Greenhall's. It closed on 13 July 2013 and was demolished in 2017. The first Mass at the first Catholic church for Grange Park took place in a converted shippon (cowshed) at Layton Hill Convent on 30 January 1949, and the church of Christ the King opened on Chepstow Road on 13 June 1954. The church, social club, youth club and presbytery were demolished in 2016/7 and the current church

The Grange, Grange Park.

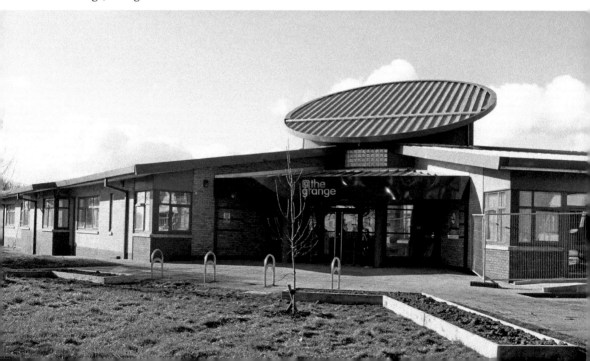

opened on 11 September 2014 on Rodwell Walk. The Church of St Michael and All Angels on Dinmore Avenue/Calvert Place was founded in 1958 and closed in around 1990s. It is now the site of a vicarage housing the SHJC Sisters of the Holy Child Jesus. The City Learning Centre building on Bathurst Avenue, with the local library and café area, is currently being changed to 'The Grange' and will include new shops and pharmacy.

Gynn Inn

The whitewashed Gynn Inn dates from *c.* 1740 and was originally a farmhouse. It was one of Blackpool's earliest places for accommodation, taking in seasonal visitors. The building later became a grocers and beerhouse and a public house in around 1850. It was situated on the site of what is now the large roundabout at Gynn Square. The photograph shows the Gynn Inn before it closed on 2 May 1921. It was demolished in August 1921 to make way for the new road and tramway extensions after the incorporation of Bispham into the Borough of Blackpool. Granny Alice Ashworth, who had been the landlady for its last twenty-five years moved to Uncle Tom's Cabin, which was managed by her daughter. Its licence was transferred to the nearby Savoy Hotel.

Gynn Inn.

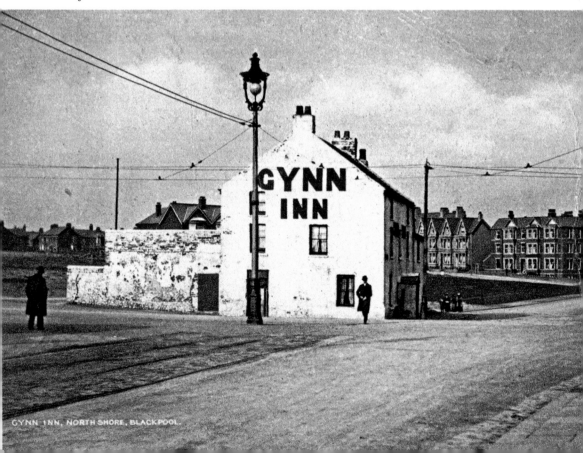

GYNN INN, NORTH SHORE, BLACKPOOL.

Hounds Hill

Blackpool's only indoor shopping centre, the Hounds Hill Shopping Centre, opened in 1980 and largely occupies the block of what was the old and somewhat ramshackle property of the streets 'behind the Tower'. These were Tower Street, Water Street, Board Street and Sefton Street, as well as the south side of Victoria Street. Along the south side of Victoria Street in the 1960s there was Henry's, Ernest Wilson & Son, the Famous Army Stores, Ernest Flower's menswear shop, Collette's (ladies fashion), Pickups (babywear), the Stanley Restaurant, Haslams Hairdressers, Victoria Street Independent Church, Wimpy Bar and New Day (furnishings), to name a few. The shopping centre was extended in September 2008 onto the land between Sheppard Street and Coronation Street with Debenhams as the 'anchor' store. A third phase is now planned for the area bounded by Coronation Street and Tower Street.

Hotels and Guest Houses

Blackpool slowly developed as a place people visited to 'take the air' from the mid-1700s. Along the seafront from Fumblers Hill (now Cocker Square) to Foxhall (Princess Street) places of accommodation were erected such as Forshaw's Hotel (later the Clifton Arms, now the Ibis Styles Hotel), Bailey's Hotel (now the Metropole), The Lane Ends (south corner of Church Street

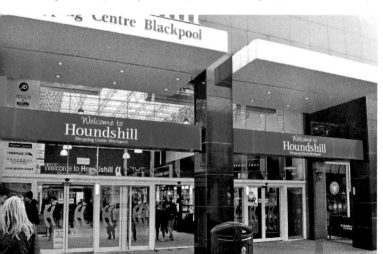

Hounds Hill.

and the Promenade) and Hull's Tavern (later the Royal Hotel – later part of the Woolworths site), Bonny's (at the junction of Chapel Street and Central Drive) and Yorkshire House (on the seafront near to where Yorkshire Street is today). The opening of the railway into Blackpool (Talbot Road station, 1846) and the opening of North Pier (1863) and later South Pier (1868) – now named Central Pier – together with the greater number of holidays of the working class and easier accessibility by railway of seaside towns to the industrial centres of the north-west, led to the rapid expansion Blackpool experienced in late 1800s. Over a million visitors arrived by train in 1879. Following the opening of South Pier in 1893 and the Tower in 1894, this rose to almost 4 million a year in the period before the First World War. To house visitors, hotels and guest houses of all standards were built or converted from residential property, primarily along the Promenade or in the streets very close to it. The Imperial Hotel opened in 1867 and more 'select' hotels such as the 'Savoy' (1915) along the quieter north side of the town opened along Queen's Promenade. To cater for the working classes, 'bed and breakfast' boarding houses where rooms could be shared in the early years and food provided or not, spread into the streets away from the promenade, such was the seasonal demand. The closure of Central station in 1964, the changes in the expectations and fall in the number of visitors from the 1960s and the move towards day trippers becoming the dominant form of visitor, led to the demise of the guest house. Blackpool has fought the decline and offers a wide range of attractions and facilities to the widest audience.

Hebrew Synagogue

The Blackpool Hebrew Congregation, founded in 1898, first held services at temporary premises in Church Street until April 1900, when they moved to Springfield Road. In 1907 the Blackpool Hebrew Congregation merged with the Blackpool New Orthodox Hebrew Congregation (founded in 1905) to form the Blackpool United Hebrew Congregation. The red-brick synagogue in Leamington Road, with its octagonal dome and stained-glass windows depicting scenes from the Torah, including the Twelve Tribes of Israel, was consecrated in 1916 and deconsecrated and closed in May 2012. The building is a Grade II-listed building.

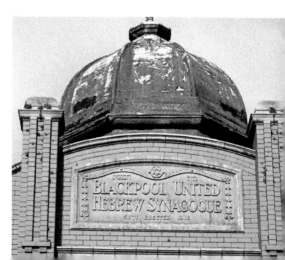

Blackpool United Hebrew Synagogue.

Illuminations

Blackpool Illuminations, which run each year at the end of the holiday season, are probably as famous as the Tower and are often said to be 'the greatest free show on earth'. Tramcars were first illuminated to mark Queen Victoria's jubilee on 22 June 1897 and the first static display was in May 1912 when Princess Parade was illuminated for its opening by HRH Princess Louise. This was followed by lighting strings of electric lamps from the Gynn to Victoria Pier in 1913. The First World War stopped the lights and they didn't return until 1925 with the animated tableaux at Bispham being introduced in 1932. The lights stopped again in 1939 at the outbreak of the Second World War and restarted in 1949, with film-star Anna Neagle switching them on. They have run each year since then with the 'Switch-On' having become a weekend of festivities. The Illuminations are now over 10 km long, with over a million lamps, illuminated tramcars, 3D light shows and the Tower with over 225,000 LED lights.

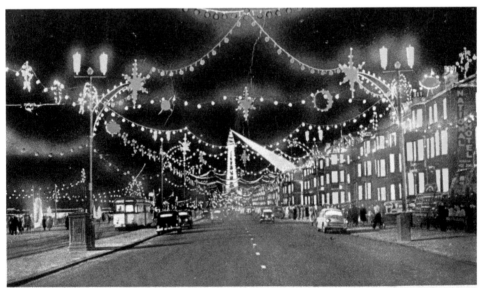

THE PROMENADE, BLACKPOOL ILLUMINATIONS. L.7957

Illuminations.

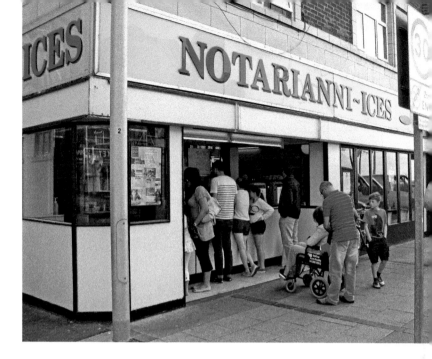

Notarianni
ice cream.

Ice Cream

Whether the sun is out or not, an ice cream while at the seaside is a must. Today, Blackpool's most famous ice cream is the vanilla ice cream made by the Notarianni family. They first opened an ice-cream parlour in 1928 on Central Promenade and later opened a second shop in around 1937 on Waterloo Road, which now opens seasonally. There was also Pablo's ice-cream factory in an alley between Albert Road and Adelaide Street, with its parlour on the promenade corner of Station Road, Peeney's (on Adelaide Street), Pye's at the Pleasure Beach and then there were the many ice-cream van stands on the beach, which were monopolised by the Naventi family until the 1960s.

Imperial Hotel

The Imperial Hotel was completed in June 1867 by the Blackpool Land and Building Co. on North Promenade in the area formerly known as the Claremont Park Estate in a red-brick, French Renaissance style. An additional wing was added in 1875. The four-star hotel has had many famous guests including the Queen, the Queen Mother, Charles Dickens, many former prime ministers, Fred Astaire, Errol Flynn, Gracie Fields and the Beatles. In 1901 a ballroom was added that could hold 400 guests, and during the 1970s the ballroom was used for concerts with bands such as Joy Division, Judas Priest, UFO and Racing Cars performing there. In the 1970s and '80s the basement housed Trader Jacks, a Polynesian-themed nightclub. The billiard room was converted into what is now the No. 10 bar, named to celebrate the nine sitting prime ministers who have stayed at the hotel.

Jaguar – Sir William Lyons

William Lyons was born on 4 September 1901 and brought up on Newton Drive. He attended Poulton-le-Fylde Grammar School (a preparatory school) and later Arnold School on Lytham Road. He met William Walmsley in 1920. Walmsley had built a stylish sidecar in 1920 and the two went into partnership and traded from No. 5 Bloomfield Road as Swallow Sidecar Co. from 11 September 1922, displaying the Swallow at the London Motorcycle Show that year. In 1926, the company rented larger premises in Cocker Street and they built their first car, the Austin Swallow Seven, in May 1927. Outgrowing their Blackpool premises, the company moved to Coventry in October 1928 and later became Jaguar Cars in 1945, making luxury cars and holding royal warrants from Elizabeth II and Prince Charles.

Jenkinson's

From around 1875 the Jenkinson sisters ran a high-class confectioners, café and restaurant at the Talbot Square premises opposite the Town Hall. It had a cast-iron canopy at the front and it is reported the oak staircase in the café was made from timber salvaged from the wrecked *Foudroyant* ship. It was bought by the Lobster Pot Group in 1960 and run as the Mövenpick restaurant in the 1960s, before becoming Jenkinson's Bar, known as 'Jenks', with Lucy's Bar downstairs. It was Rumours from 1983 to 2014, becoming the Nyx Bar and is now Home.

Jenkinson's.

K

Kiss Me Quick Hats

Kiss Me Quick hats have traditionally been worn by working-class visitors to seaside resorts and are associated with an intention to have some fun. The origin of the Kiss Me Quick hat is unknown but may derive from America where the phrase is found in early songs or it may be related to a homemade quilted bonnet used by ladies when going to parties or the theatre.

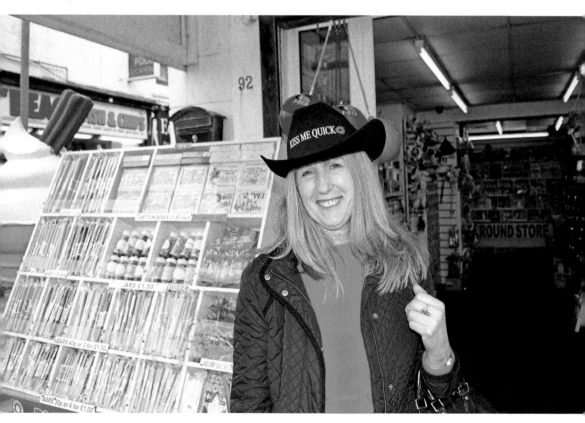

Kiss Me Quick hats – Norma Fowden.

King Edward Hotel and Cinema

The cinema on Central Drive was originally named the Central Picture Theatre. It was opened on 1 July 1913 and is a Grade II-listed building. It was renamed the King Edward Picture Palace in 1914 and closed in 1972. It became a bingo hall until 1984, after which it was restored and converted to Village Pizzeria in spring 1986. Later it became The Venue nightclub and then an entertainment venue named Family Fun, before closing in 2011. It is now vacant. The adjacent King Edward VII Hotel, on the corner of Chapel Street and Central Drive (formerly Great Marton Road), opened in 1903 and stands on the westerly part of Bonny's Farm (demolished in 1902), one of Blackpool's oldest lodging houses. It is a large open pub with a central bar and has retained a few etched windows on the frontage advertising 'Marshall and Co. Ales'.

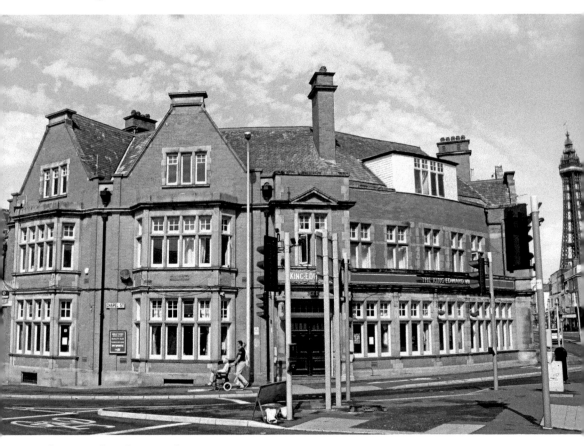

The King Edward VII Hotel.

L

Lifeboats

The first Blackpool lifeboat was the 33-foot by 8-foot *Robert William*, which was first launched on 20 July 1864. The boat was housed in a new boathouse on Lytham Road just behind where the Manchester is today. The *Robert William* served until 1885 and in that period is credited as saving eighty-one lives. The *Samuel Fletcher* arrived on station in September 1885 and served until 1896 and saved twenty-one lives. A second *Samuel Fletcher* lifeboat arrived in December 1896 and rescued twenty-eight men from the wrecked *Foudroyant* on 16 June 1897. The lifeboat was purchased by Blackpool Corporation in 1930 and used as a pleasure craft on Stanley Park Lake. The *John Rowson Lingard* lifeboat served for seven years and was replaced in 1937 by the *Sarah Ann Austin*, which was housed in the new lifeboat station adjacent to Central Pier. The *Maria Noble* arrived in 1961 and served until 1970. The *Edgar George* served between 1970 and 1975. The new lifeboat station and visitor centre on Central Promenade, seen in the photograph, was completed in September 1998 and today the *William & Eleanor* B Class and two D Class lifeboats are in service.

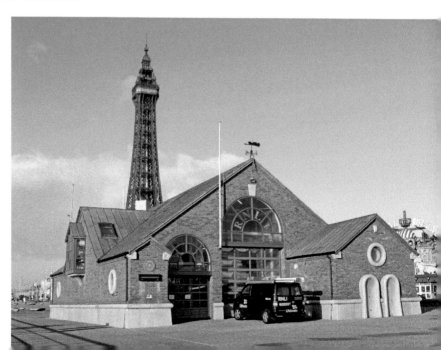

Lifeboats.

Layton.

Layton

The village of Layton appears in the Domesday Book (1086) and is recorded as being of some 720 acres of arable land. It was given by William the Conqueror to the first Baron of Warrington, Pagan de Villers, and subsequently passed to the Butler family. In 1257, William Butler obtained a charter from Henry III to hold a market in Layton on Wednesdays and a fair between 29 November and 1 December each year. The Layton estates were sold in the mid-1500s and were owned in 1550 by Thomas Fleetwood. His absentee son William began to sell off a large part of the estate. Roger Hesketh married Edward Fleetwood's daughter in 1733 and there being no male (Fleetwood) heir, Roger became lord of the manor. The Layton Hall estate was sold to the Clifton family in 1841 and the Layton-cum-Warbreck Board of Health was formed in 1851.

Layton Hill Convent

From 1856 the Sisters of the Society of the Holy Child Jesus taught girls at a school in Talbot Road. The first St Mary's school was located at Raikes Hall in 1860 before the Sisters moved to the Layton Hill site in 1870. In 1975, the school merged with St Joseph's to form St Mary's Catholic College and Sister Maureen Grimley (SHCJ) (1932–2007) became the first head teacher of the combined school. In 1982 the school merged with the St Thomas of Canterbury's and St Catherine Schools. It is now St Mary's Catholic Academy on St Walburgas Road, Layton, the largest Roman Catholic secondary school in Lancashire.

Layton Hill Convent.

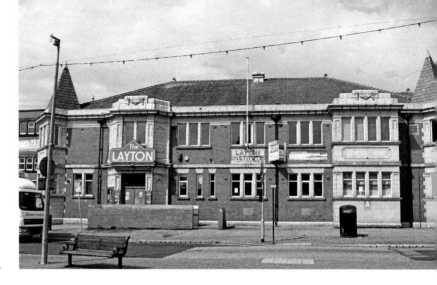

Layton Institute.

Layton Institute

Layton Institute was first housed in a barn at Little Layton from 8 November 1912 and then moved to a bungalow on the east side of Westcliffe Drive near to Lynwood Avenue. The foundation stone for Layton Institute was laid in June 1925 and with its large snooker room, bowling green and concert room was probably Blackpool's premier working men's club for decades, famous for the acts who appeared there over the years. The institute closed on Sunday 12 August 2012 and reopened as The Layton pub.

Lemon Tree – Squires Gate Hotel

The Lemon Tree nightclub and casino was developed from the Squires Gate Hotel, built in 1939, on the corner of Squires Gate Lane and Clifton Drive North (technically in St Annes). The building also housed the Squires Gate pub, a Greenhall's Brewery pub. The Lemon Tree was owned by the Levine family and the nightclub comprised the Club Room where Erskine was the head barman for several years, the Pagoda Room with its tropical ambience and circular revolving stage, as well as the disco upstairs. It closed in 1983 and the site is now occupied by Lemon Tree Court, comprising sixty-three retirement flats, built in 1994.

Lewis's

Lewis's department store at No. 50 Promenade opened on 2 April 1964 and was built on the site of the Palace Theatre and County Hotel. It had a distinctive white honeycombed façade on the seafront elevation with a turquoise tiled wall behind. Its five floors instantly rivalled RHO Hills as Blackpool's premier department store with its escalators to all floors, basement Food Hall, ground-floor perfumery area, first-floor fashions and Martins Bank (Lewis's

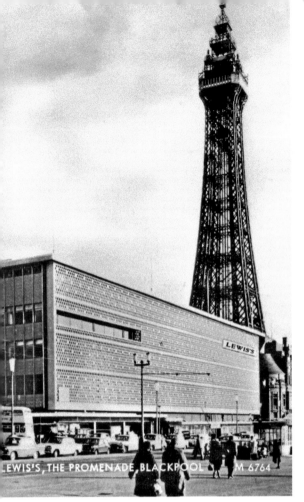
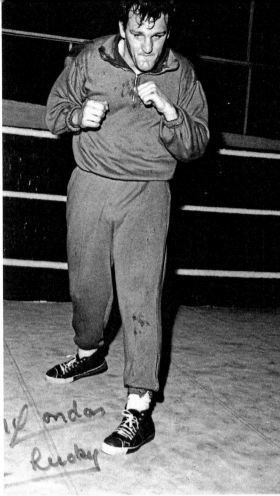

Above left: Lewis's. *Above right*: Brian London.

Bank), ladies' hairdressing department and beauty salon on the second floor and record store and Wardroom Restaurant with its 80-foot picture window overlooking the Irish Sea on the third floor. It had an excellent Santa's grotto every year. Lewis's closed on 9 January 1993 and the site was redeveloped with the top two floors being removed. The remodelled building was mainly occupied by Woolworth's and Harry Ramsdens. The site now houses several stores including Poundland.

London, Brian

Born Brian Sydney Harper in West Hartlepool, County Durham, on 19 June 1934, Brian was the British and Commonwealth Heavyweight Champion between 1958 and 1959. He boxed for the world heavyweight title twice, losing to Floyd Patterson in the eleventh round in 1959 and Mohammed Ali in 1966. His last fight was with Joe Bugner at Wembley in May 1970. After retiring, Brian ran several nightclubs in Blackpool, including the famous 007 nightclub with its main entrance on Tower Street.

M

Mortensen and Matthews

Stanley (Stan) Harding Mortensen (26 May 1921–22 May 1991) was born in South Shields and played for Blackpool between 1941 and 1955, scoring 197 goals. He remains the only player to have scored a hat-trick in a FA Cup final, which he did on 2 May 1953. He managed Blackpool in 1967–69 and died, aged sixty-nine, in 1991. Stan Mortensen Avenue (off Princess Street) has recently opened and is named after Stan. Sir Stanley Matthews CBE (1 February 1915–23 February 2000) was born in Hanley, Staffordshire, and was the first professional footballer to be knighted. He played for Stoke City from the age of fifteen and signed for Blackpool in 1947 and played for them for thirteen years. He played for England eighty-four times and is the oldest player to play for England at forty-two years and 103 days. He was the first European Footballer of the Year in 1956 and played his last top-flight game for Stoke in October 1961, at the age of fifty. He is considered by many to be the greatest footballer ever.

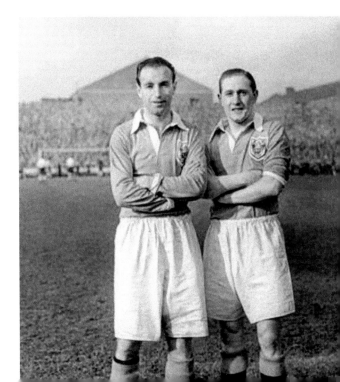

Mortensen and Matthews.

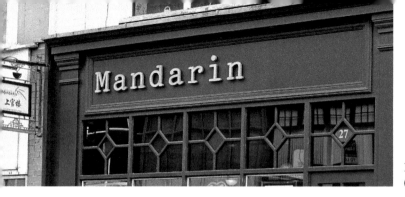

Mandarin
(restaurant).

Mandarin Restaurant, Clifton Street

The Mandarin at No. 27 Clifton Street was the first oriental restaurant in Blackpool and was opened in 1961 by Michael Wan. When Michael retired in 2015, Pauline Lai took over and is now the owner.

Marton Mere

Marton Mere is a glacial freshwater lake on the outskirts of Blackpool. It is now a local nature reserve and is recognised as a Site of Special Scientific Interest for its bird populations and is also an important habitat for butterflies, dragonflies, bats and orchids. The Mere was originally some 2 and a half miles long and 1 mile wide before being drained in 1731 and further in 1741 by the Jolly family of nearby Mythop, the reclaimed land being used for agricultural purposes.

Miners' Convalescent Home (Admiral Point)

The Miners' Convalescent Home on Queen's Promenade, Bispham, was built between 1925 and 1927 for the use of Lancashire and Cheshire coal miners and was opened by Edward, Prince of Wales, on 28 June 1927. It was designed by Bolton architects Bradshaw, Gass &

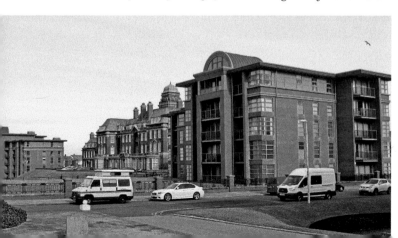

Miners'
Convalescent Home.

Hope in the Baroque Revival style and is now a Grade II-listed building. It closed in 1987 and after remaining empty for a number of years, the main building was refurbished in 2005 and converted into apartments. Two new six- and seven-storey apartment buildings named Admiral View and Admiral Heights were constructed.

Miss Blackpool (beauty pageants)

Miss Blackpool beauty pageant competitions were held sporadically during the 1920s and 1930s and the first official Miss Blackpool beauty contest held in 1954 was won by Elaine Smith. The contest was originally known as the Blackpool Bathing Beauty Queen Competition and was held at the open-air swimming pool, South Shore. Later competitions were held in the North Pier Sun Lounge, Brannigans Bar on Bank Hey Street, the Norbreck Castle Hotel, the Hilton Hotel and the Pleasure Beach Paradise Room. Miss Blackpool 2017 is Shannon Marie Hamill.

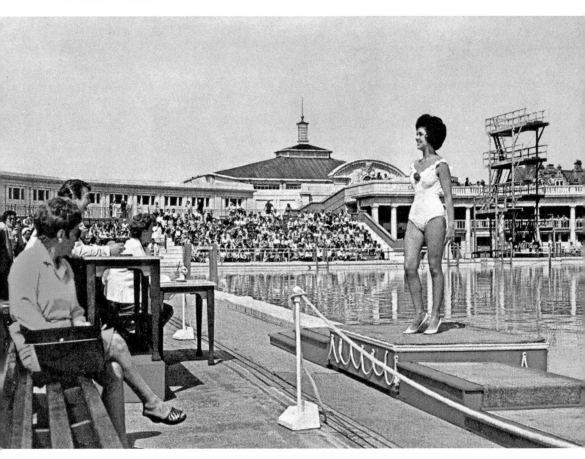

Miss Blackpool (beauty pageants).

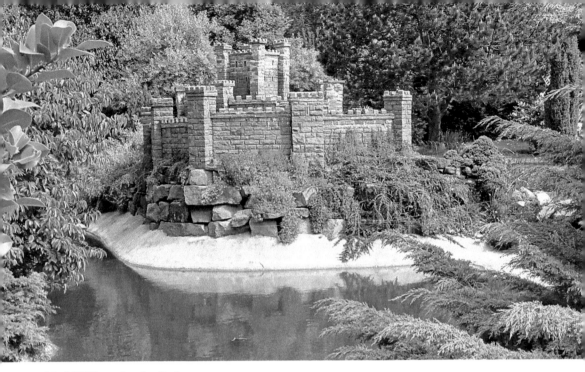

Model Village, Stanley Park.

Model Village, Stanley Park

Blackpool Model Village and Gardens opened on a 2.5-acre site at East Park Drive in 1972. The hundreds of hand-made model buildings and figures represent everything from a Cornish fishing village to a Scottish castle. It is open from late March to November each year.

Morton, Lucy

Born in Knutsford on 23 February 1898. Lucy was a world record holder and the first woman to win a swimming gold medal for Great Britain at an Olympic Games, which she did in the 200-metre breaststroke event in the 1924 Paris games. Lucy married Harry Heaton in 1927 and taught swimming for Blackpool Corporation from 1930 to 1972. Lucy died in Blackpool on 26 August 1980.

Motorcar Races and Motorcycle Sprints

Motorcar races along the Promenade were regular events in Blackpool in the early 1900s and were watched by thousands. In the speed trials of October 1906, Dorothy Levitt broke her own women's world speed record with a speed of 90.88 miles per hour. The annual motorcycle sprint ran on the Lower Promenade at Bispham but ended in 2001, on safety grounds, after more than forty years.

N

North Station

The first railway into Blackpool opened as Talbot Road Station on 29 April 1846 (renamed North Station in 1872) and fronted on to what was to become Dickson Road at its corner with New Road (later renamed Talbot Road). The original terminus building was classical in style but some will remember its 1898 red terracotta and brick replacement with its clock tower and its large cast-iron and glass canopy over the entrance. The buildings fronting onto Dickson Road were demolished in 1974 and the terminus moved back to east of High Street (as seen in the photograph). Various supermarkets have occupied the Dickson Road/Talbot Road site since. Blackpool North station has been upgraded and the line to Preston was electrified in 2017–18.

North station.

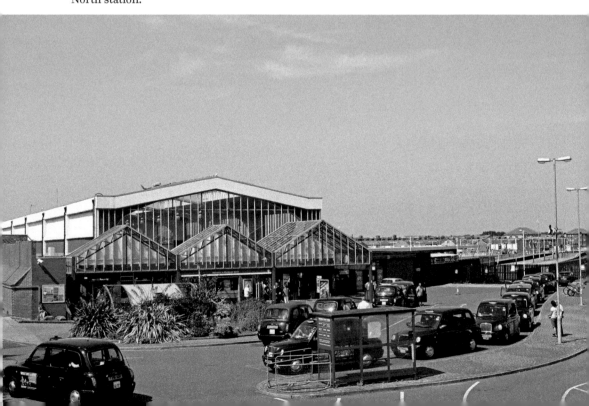

National Savings (ERNIE)

The Premium Bonds office on Mythop Road, Marton, housing ERNIE (Electronic Random Number Indicator Equipment) was moved to Blackpool in 1978. It was an unusual building as many thought it was an airport control tower. The eight-storey tower at the National Savings & Investments site was demolished (blown up) on 26 February 2017 and over 100 houses are to be built on the site.

Nolans, The

The Nolan family of Tommy and Maureen Nolan and their (then) seven children came to Blackpool from Dublin in 1962 and became the Singing Nolans in 1963. The group comprised Tommy and Maureen Nolan, Tommy (1949), Brian (1955), Anne (12 November 1950), Denise (9 April 1952), Maureen (14 June 1954), Linda (23 February 1959) and Bernadette ('Bernie', 17 October 1960–64 July 2013). Coleen, the eighth child, was born in Blackpool on 12 March 1965 and joined the group full time in 1980. They moved to London in 1973 and the Nolan Sisters group was launched in 1974, becoming The Nolans in 1980. They are best known for their hit single 'I'm In the Mood for Dancing', released in December 1979, reaching No. 3 in the UK charts. The Nolan sisters have (together and individually) had remarkable careers. Sadly Bernie died of cancer on 4 July 2013.

The Nolans, 2009.

Norbreck Hydro.

Norbreck Hydro

The first hotel on the site was James Shorrock's modified Norbreck Villa, becoming Norbreck Hall Hydro in 1905. The first large wing was built in 1912 and the second in the mid-1930s, with the modern extension to the north end built in the early 1970s. There were tennis courts to the front of the hotel (now the car park) and bowling greens and an eighteen-hole golf course to the rear.

No. 3

The No. 3 and Didsbury at Devonshire Square was originally an inn at the junction of the old road from Poulton-le-Fylde, Layton and Whitegate Lane into Blackpool. It has existed since at least the late eighteenth century and is one of Blackpool's oldest pubs. It had a bowling green at the rear until the mid-1960s, which inevitably became a car park. It was known as the Crown for a short period around 2010 and is now the No. 3, part of Greene King's Flaming Grill chain.

Odeon (later Funny Girls)

The white and green faience-clad Odeon, fronting onto Dickson Road, is a Grade II-listed building (listed in 1994) and was officially opened as an Odeon Cinema on 6 May 1939. It had a seating capacity of 1,684 in the stalls and 1,404 in the balcony. The building was designed by Robert Bullivant of Harry Weedon & Partners in the 1930s art deco style. It was converted to three screens (triplexed) in 1975 but closed on 5 December 1998. After a period of disuse it was reopened in 2003 by Basil Newby and operates as Funny Girls and the Flamingo nightclub, accessed from Queen Street.

Funny Girls, once an Odeon Cinema.

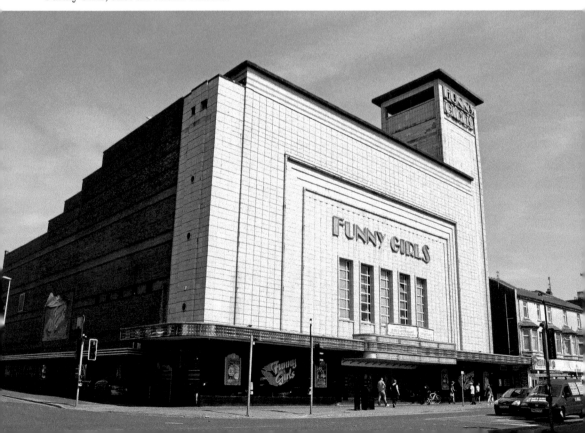

Opera House

The original Her Majesty's Opera House on Church Street opened on 10 June 1889 and was designed by Frank Matcham. In 1910–11, it was enlarged and the Church Street façade was rebuilt in a Renaissance style and clad with white faience. The Opera House was demolished in 1938 and the 3,000-seat replacement theatre opened on 14 July 1939. The theatre staged the first Royal Command Variety Performance outside of London on Wednesday 13 April 1955, in front of the Her Majesty the Queen and HRH the Duke of Edinburgh. It also staged the eighty-first Royal Variety Performance in the presence of Her Majesty the Queen on 7 December 2009, which was compered by Peter Kay.

Oxford, The

In the early 1870s the Oxford was originally the Mill Inn, named such due to the adjacent windmill. It became the Oxford Hotel around 1889 and later was owned by Catterall & Swarbrick. In 2007 it was renamed Bickerstaffes. It closed in 2009 and was demolished in 2015. The site is now occupied by an Aldi supermarket, as seen in the photograph.

Aldi – Oxford Hotel site.

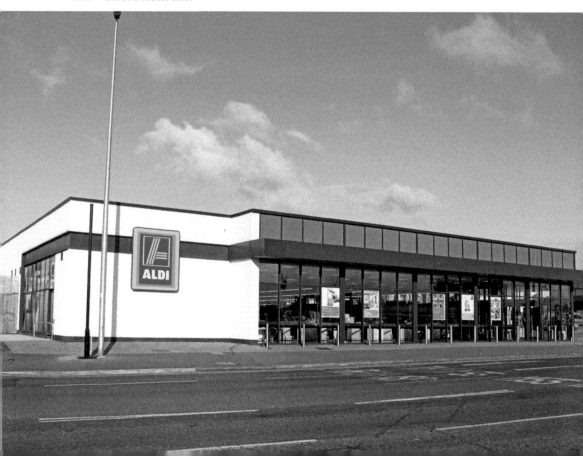

Pleasure Beach

In the 1880–90s, with trams terminating at Dean Street (1885) and Victoria Pier opening in 1893, the sandhills area of South Shore, south of Balmoral Road, became an unorganised fairground. In 1903 William Bean and John Outhwaite purchased the Watson estate lands and began to develop what would become the Pleasure Beach amusement park. The first major attraction to be built was Sir Hiram Maxim's Captive Flying Machine in 1904, followed by the River Caves of the World in 1905 and the Scenic Railway in 1907, the park's first wooden roller coaster. In the period 1922–26, the promenade between South Pier and Starr Gate was widened and the Pleasure Beach was established in its current location. The famous Big Dipper wooden rollercoaster was opened in 1923 and was extended in 1936. William Bean died in 1929 and his daughter Lillian-Doris, who married Leonard Thompson, inherited the Pleasure Beach business. Leonard managed and developed the company for forty-seven years until his death in 1976. In this period they engaged architect Joseph Emberton to design rides and buildings in the modernist style. Geoffrey Thomson OBE was managing director from 1976 until he died in 2004. In this period the 235-feet-high, record-breaking Big One opened (28 May 1994), as well as the Steeplechase, Avalanche and Revolution. Doris Thompson died in 2004 shortly after her son's death and the business has been run since 2004 by Geoffrey's daughter Amanda Thompson OBE and her brother Nick. In 2011, a contract was signed to open Nickelodeon Land, the Red Arrows Sky Force ride was opened in 2015, the award-winning Valhalla ride was opened in 2016 and the new £16.25-million rollercoaster named ICON will open in 2018.

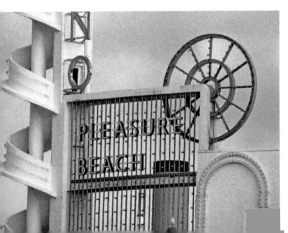

Pleasure Beach.

Parkinson, Sir Lindsay

Albert Lindsay Parkinson was born in Lytham on 24 February 1870, the second of four sons of the seven children of Jabob and Mary Parkinson. Jacob was a joiner and had a company named Jacob Parkinson & Co. in Blackpool and Alfred and his brothers worked in the business. By the early 1900s they were taking on larger projects including the Alhambra Theatre in Blackpool and continued to expand after the First World War into large-scale housing schemes. Albert was mayor of Blackpool (1916–18), Member of Parliament (1918–22) and was knighted in 1926, at which time the company took his name. Albert was chairman and president of Blackpool Cricket Club and generously donated monies to build the cricket ground and pavilion around 1924. In 1957 his company began the construction of the first motorway, the M6 Preston Bypass. The company was taken over by Leonard Fairclough & Son of Northwich in August 1974.

Penny Stone and Carlin Stone

In local folklore it is said that the Penny Stone was near to a public house in the village of Singleton Thorpe, which was inundated by the sea and lost around 1555, and that travellers tied their horses to a ring on the stone. Thornber in his 1837 *History of Blackpool*, while not denying the probable existence of villages to the west of the current land, doubts the story of the ring in the stone and surmises that the stone probably fell from the cliffs as they eroded over time. The Penny Stone (seen in the photograph) is located at the low water mark and is only accessible at very low tides. It is some 200 metres north-west of the Carlin Stone. The Carlin Stone is marked on various Ordnance Survey maps and is located approximately opposite Pennystone Road, Bispham.

Penny Stone.

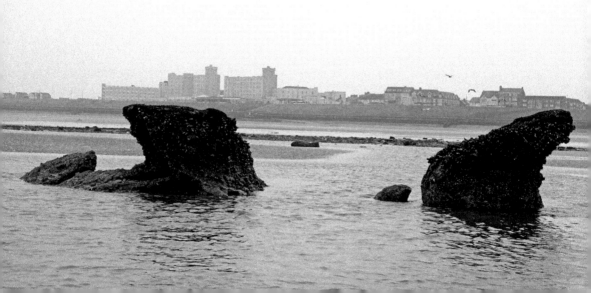

Pet Shop Boys – Blackpool Musicians

Formed in London in 1981, the Pet Shop Boys consist of Neil Tennant and Chris Lowe. They have had forty-two top-30 UK singles, including four No. 1 records. Chris Lowe was born in Blackpool on 4 October 1959 and attended Arnold School. Lowe is famous for his understated public presence. *The Guardian*, in 1995, stated he was 'possibly more famous for not doing anything than almost anyone else in the history of popular entertainment'. Other notable musicians from Blackpool include, Ian Anderson, John Evan and Jeffrey Hammond of Jethro Tull, David Ball (of Soft Cell), singer-songwriter Roy Harper; Nick McCarthy (of Franz Ferdinand); Graham Nash (of The Hollies/Crosby, Stills, Nash & Young), folk singer Maddy Prior; Victoria Christina Hesketh (Little Boots); and Rae Morris.

Piers

Blackpool is unique in the UK in having three piers. The first pier to be built was North Pier, built by the Blackpool Pier Co. and opened with great pomp and ceremony on Thursday 21 May 1863. North Pier was originally a simple structure and has since been extended (although the jetty has been removed), widened and pavilions have been erected at both ends over the years. Following the success of North Pier it was decided to build a second pier, which opened on 30 May 1868 and originally known as South Pier, but was renamed Central Pier when Victoria Pier (South Pier) opened on Good Friday, 31 March 1893. North Pier and Central Pier each had a jetty. Pleasure (paddle) steamers ran daily excursions to places like Douglas (IoM), Llandudno, Southport, Morecambe and Fleetwood, with steamers named *Queen of the North*, *Greyhound*, *Belle*, *Bickerstaffe* and *Wellington*, to name a few. In 1900 the return fare to Douglas was 6s and included all pier tolls.

North Pier.

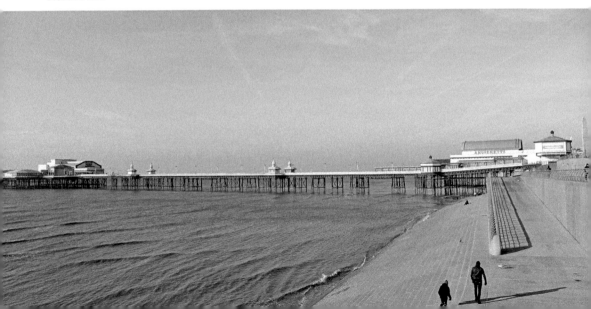

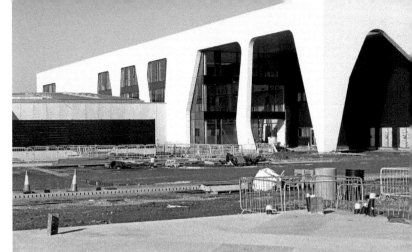

Clifton Road
police headquarters.

Police Stations

Blackpool's first police station (*c.* 1853) was on the east side of Bonny Street. It was replaced by Abingdon Street police station (now the market site), which was built in 1862 and housed a courthouse, offices and cells. At that time it was between Abingdon Street and Edward Street and running parallel to them was Police Street. The Blackpool Borough force was formed in 1887 and the Abingdon Street police station closed in May 1893, with the force moving into new premises on Lower King Street, now South King Street. New premises and law courts were built at the junction of Bonny Street and Chapel Street in 1976. New premises for Lancashire Constabulary's West Division on Clifton Road, Marton, are currently under construction, as the photograph shows, and are due to be completed in 2018 after which the Bonny Street building will be demolished.

Postcards

The sending of picture postcards started in the mid-1890s and became a craze in Edwardian times, when countless millions were sent from seaside resorts. The main topics seen on old Blackpool postcards are generally the Tower, the three piers and the promenade, but

Postcards.

postcards showing the hotel/boarding house where the visitor was staying, rough seas, donkeys, trams, the Pleasure Beach and the Illuminations are also common. Many comic postcards were also produced, and there were soon concerns about the decency of such cards. Blackpool had two separate postcard censorship boards: one before the First World War and one established in 1951 as part of a crackdown on what was seen by some as lax moral standards. By the early 1950s some retailers were being prosecuted under the 1857 Obscene Publications Act without any guidance as to which cards could or could not be sold. The Blackpool Censorship Board of 1951 was a civilian committee made up of a vicar, landlady, bank manager (retired), solicitor and a stationer. Around 20 per cent of the comic postcards submitted to the board by publishers were disapproved. The decision of the board was final, and if a card passed the censors' eyes it would not be prosecuted by magistrates in town. The Censorship Board lasted until 1968.

Punch and Judy

Unique Punch and Judy shows with the crocodile, the Bobby, the hangman, the clown and others have been staged on the sands at Blackpool since the 1880s. Most well known were the generations of the Green family who, with their performing dog, performed for over a 100 years until the retirement of Joe Green in 1987.

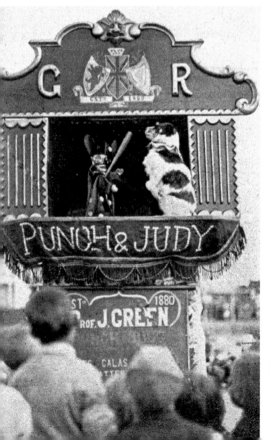

Punch and Judy.

Political Party Conferences

The major political parties regularly held their annual conferences at the Winter Gardens for many years but the last Labour Party conference was in 2002 and the last Conservative Party conference was in 2007.

Putting and Crazy Golf

Putting and crazy golf were popular forms of entertainment in times gone by and indoor venues with modern variants are now opening. Besides putting at Stanley Park, there were putting greens at Anchorsholme Park and crazy golf near Norbreck tram stop; near Bispham Tram station; Gynn Gardens; Pembroke Gardens, in the sunken gardens to the north of the Metropole; the Pleasure Beach and at Starr Gate.

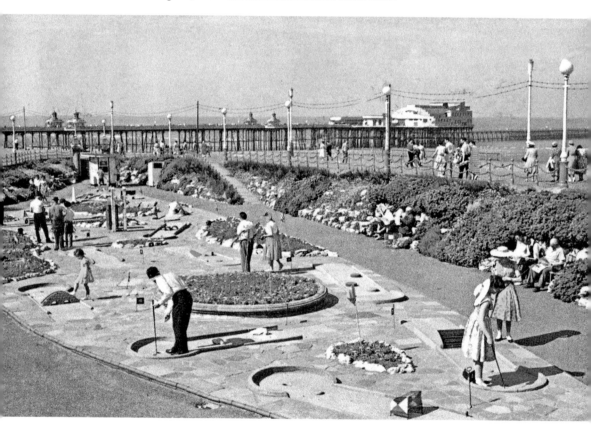

Putting and crazy golf.

Queenstown

The Queenstown area of Blackpool was developed in the mid-1800s after New Road (later Talbot Road) was built from North station to Layton. Today it is known as Queens Park and is south of Talbot Road and east of Devonshire Road. The terraced houses of Wildman Street, St Joseph Road, Thomas Street and Ward Street were demolished in the early 1960s to make way for the sixteen-storey Charles Court, Ashworth Court, Elizabeth Court and Churchill Court, with the twenty-two-storey Walter Robinson Court being completed in 1972. All of the tower blocks were demolished in 2014–2016, and a mix of apartments and two-, three- and four-bedroom houses have been built and are managed by Blackpool Coastal Housing.

Queenstown.

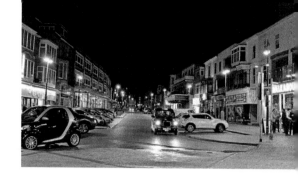

Queen Street.

Queen Street

This once genteel street, with its bowling green (site of Central Library), vicarage (site of the car park adjacent to Central Library and the Grundy Art Gallery), Christ Church (founded in 1866–1982) on the corner of what was then Parker Street (now Abingdon Street) and up-market shops down to Queen Square has, in recent years, been transformed into the main town centre area for late night bars. In the 1960s shops included Caves Corner (from 1927 but closed in December 2017), Standerwicks china shop, Camille shoe shop, a fur coat shop and lingerie shop. The Employment Exchange (later the Job Centre) was for a long time on the north side where Litten Tree pub is now before it moved to new premises on the corner of Queen Street/Abingdon Street. The buildings on the corner with the Strand were the original venue for Funny Girls in 1994 and is now Walkabout.

Queen's Theatre

A theatre originally opened on this Bank Hey Street site on 3 September 1877, named the Borough Theatre. It closed after two years and became Bannister's Borough Bazaar. The theatre was rebuilt in 1928 and renamed Feldman's Theatre (after the music publisher Bertram Feldman). In 1938 the building was extensively renovated and in 1951 it was sold to Jimmy Brennan. It reopened in 1952 as the Queen's Theatre, with a spectacular summer revue titled *Singing in the Reign* starring Josef Locke. The Beatles played there twice in 1963. Freddie and the Dreamers and Susan Maughan topped the bill in 1964 and Tommy Cooper in 1965. The Queen's closed in 1971 and the building was demolished in 1973 to make way for a new C&A department store. It now houses TK Maxx.

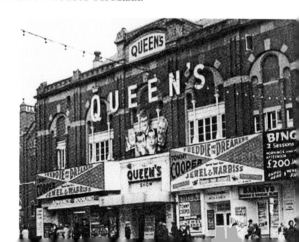

Queen's Theatre.

Radio Wave

Radio Wave is an independent radio station based in Mowbray Drive and now owned and operated by Wireless Group Ltd serving the Fylde coast. It first broadcast from 7 a.m. on 25 May 1992 through its transmitter at the top of Blackpool Tower. By 1996 it had become the areas most listened to radio station.

Rock

Blackpool is famous for its lettered rock, with 'BLACKPOOL' running all the way through it. Lettered rock is thought to have been developed in 1868 by Ben Bullock, a sweet maker from Dewsbury, and became a favourite souvenir item in Blackpool soon after. Rock is made by boiling sugar, water and glucose to 300 degrees centigrade and then cooling it and rolling it to the required size. Blackpool rock was the subject of the well-known 1937 song by George Formby 'With My Little Stick of Blackpool Rock'. Today, Blackpool's largest rock maker is Coronation Rock Co. founded in 1922.

Blackpool Rock.

Revoe.

Revoe

In the nineteenth century, the area of Revoe (approximately Palatine Road to Bloomfield Road) was farmland with few, if any, roads passing through. From around the 1860s the area first began to be developed when the terraced housing of Ibbison Street (now demolished and occupied by Ibbison Court) and Belmont Avenue were built by Thomas Ibbison off Great Marton Road (now Central Drive). The Revoe Inn (a beerhouse) at the bottom of Ibbison Street was replaced around 1863 by the George Hotel and Revoe Council School opened in 1902, with the Infants' School opening in 1911. Revoe Library and Gymnasium opened in October 1904 on the site of Revoe Farm.

RHO Hills

RHO Hills on Bank Hey Street had four floors and a basement and was for many years Blackpool's premier department store. It suffered a fire on 13 January 1932 in which police fireman William Matthews died, age forty-four. The store was extended in 1937 and suffered a further fire on 6/7 May 1967. When it reopened in 1968 thousands flocked through the doors. After the House of Fraser takeover in 1975, RHO Hills became Binns until its closure in 1987. The building now houses Primark and HMV and is part of the Hounds Hill Shopping Centre.

Roberts' Oyster Rooms

Roberts' Oyster Rooms, at the corner of West Street and the Promenade, date from the mid-nineteenth century and probably began as lodgings with a shop on the ground floor. It has served seafood since 1876, and until around 2003 the Victorian wood-panelled rooms behind the bar were open. Today, while the old façade survives, only takeaway seafood can be purchased, including oysters on a half shell, little trays of cockles, mussels, whelks, winkles and prawns.

Raikes Hall Gardens

Raikes Hall was built around 1765 by Willian Butcher and was bought by William Hornby in 1802. It was leased to the Sisters of the Holy Child Jesus in 1859 and became a convent girls' school until the lease ran out in 1870, when it was sold to the Raikes Hall Park, Gardens and Aquarium Co., and the nuns moved to Layton Hill Convent. After a competition for the design of gardens and new facilities, the grounds were partially opened on Whit Monday 1872. By 1873 the site boasted extensive gardens, a conservatory, skating rink, Indian lounge, theatre, ballroom, dancing platform, boating lake, 'Fairy Fountain' and sports pitches where Blackpool FC played in 1888–89. The impressive Portland stone entrance gates at Raikes Hill were erected in 1874 and the site became the Royal Palace Gardens in 1887 to commemorate Queen Victoria's Golden Jubilee. Due to competition from the Tower, Winter Gardens and the Piers, the gardens closed in 1898 and the land from Raikes Parade east to Whitegate Drive was sold for building in 1901.

Rugby League (Blackpool Borough)

Blackpool Borough Rugby League Club was accepted into the Rugby League in 1954 and originally played at the Greyhound Stadium in St Anne's Road until 1962, with larger fixtures being played at Bloomfield Road. In the third round Challenge Cup match against Leigh in 1957, 22,000 spectators attended the game. They played at Borough Park, Princess Street, from 31 August 1963 (beating Salford 36–16) until 4 January 1987. The club moved to Wigan, later Chorley, then back to Blackpool as the Blackpool Gladiators, before folding in 1987. The team wore tangerine, black and white jerseys.

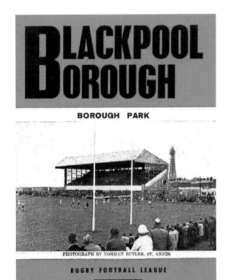

Blackpool Borough match-day programme.

S

Stanley Park

Stanley Park is Blackpool's largest municipal park. It was officially opened on 2 October 1926 by Lord Derby in around 232 acres of land with a 26-acre boating lake, three bowling greens, thirty-eight tennis courts (twenty-four hard and fourteen grass), an athletic ground with cinder track, putting courses, an eighteen-hole golf course, three cricket pitches, four football grounds, a green for hockey, a children's yacht pond and paddling pool, conservatories, botanical, rose and Italian gardens and a band-tand with seating accommodation for around 3,000. The Cocker Memorial Clock Tower was officially opened by Alderman Sir John Bickerstaffe on 29 June 1927, in honour of Alderman William Henry Cocker (1836–1911). The park remains much the same today but has been developed and now includes an indoor sports centre, a national BMX race track, skatepark, children's playground and the High Ropes Course.

Stanley Park.

Sacred Heart Church, Talbot Road.

Sacred Heart Church, Talbot Road

Sacred Heart Church on Talbot Road with its Gothic-style design by Edwin Welby Pugin was the first Roman Catholic church in Blackpool and opened on 8 December 1857. A peal of cast steel bells was added in 1866 and an organ in 1876. It was enlarged in 1894. Day and Sunday school buildings were attached to the church and these are now the Little Black Pug café/bar. The church is a Grade II*-listed buildings.

Saddle Inn

Dating from at least 1776, the Saddle Inn is probably Blackpool's oldest pub. It is famous for its separate rooms such as the House of Lords with its red leather bench seats (men only until 1975) and the Commons with its green-coloured bench seating. In 1892, William and Eliza Leigh moved from the nearby Oxford Hotel and they and their family were landlords at the Saddle until Jim (James Shepherd Leigh, the beekeeper) retired in 1967. Pam and Don Ashton started the Saddle Beer Festival in the 1970s in a marquee adjacent to the pub. The Saddle is now owned by the Stonegate Pub Co. and is an excellent real ale pub.

Saddle Inn.

Salvation Army – Blackpool Citadel

Built in 1904–05 and opened as the Blackpool Municipal Secondary School, at Raikes Parade. Around 1933 it became Blackpool Grammar School until the new grammar school was opened at Highfurlong in 1961. It is now the Salvation Army – Blackpool Citadel.

Salvation Army – Blackpool Citadel.

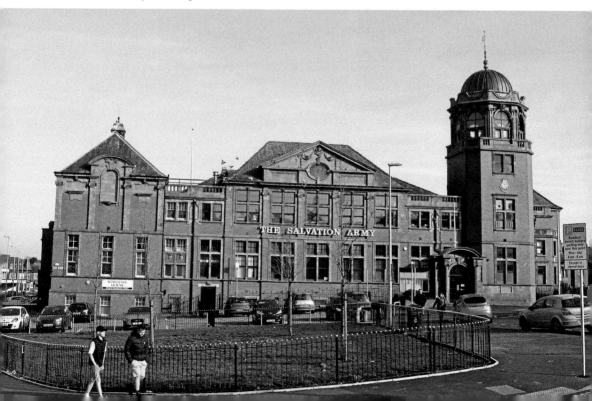

Sandcastle.

Sandcastle Water Park

The Sandcastle Water Park opened in 1986 as a joint venture between the council and private partnership on the site of South Shore Open Air Baths. It has an 84-degree-farenheit tropical climate with over eighteen slides and attractions. Blackpool Council took back ownership in 2003.

Sand, Sea and Spray – Blackpool Urban Art Festival

Sand, Sea and Spray is an urban art festival that was started by Robin Ross in 2012. Since its inception it has hosted many of the best local, national and international street artists and their work can be seen on a number of town centre walls and buildings. The photograph is of the artwork on the corner of Topping Street and Deansgate.

Sand, Sea and Spray – Blackpool Urban Art Festival.

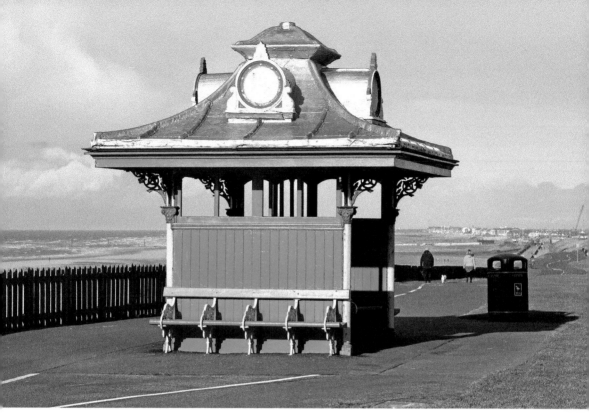

Shelter on Queen's Promenade.

Shelters on Queen's Promenade

The Grade II-listed shelters west of the tram tracks between Sandhurst Avenue and Pembroke Avenue were built around 1905. They are square in plan, with cast-iron columns at the corners, wooden side screens and partitions and a lead-covered swept out pavilion-shaped roof with a needle shaped iron finial rising from the centre. The three pairs of (c. 1905) shelters opposite Trafalgar Road, Wellington Road and Alexandra Road were removed in 2006 when the South Shore coast protection works were being carried out and subsequently renovated and relocated to Princess Parade, west of the Metropole.

Shrine of Our Lady of Lourdes

The site for the church at Whinney Heys Road was donated by local builder William Eaves and was built in 1955–57 as a war memorial thanksgiving chapel. It is a Grade II*-listed building and was built using Portland stone with a copper clad-roof, magnificent interior, raised sanctuary and bronze altar rails of art deco design. The shrine was tended by nuns of the Congregation of Adoration of Mary Reparatrix and later by the Blessed Sacrament of Fathers. It is now cared for by the Historic Chapels Trust.

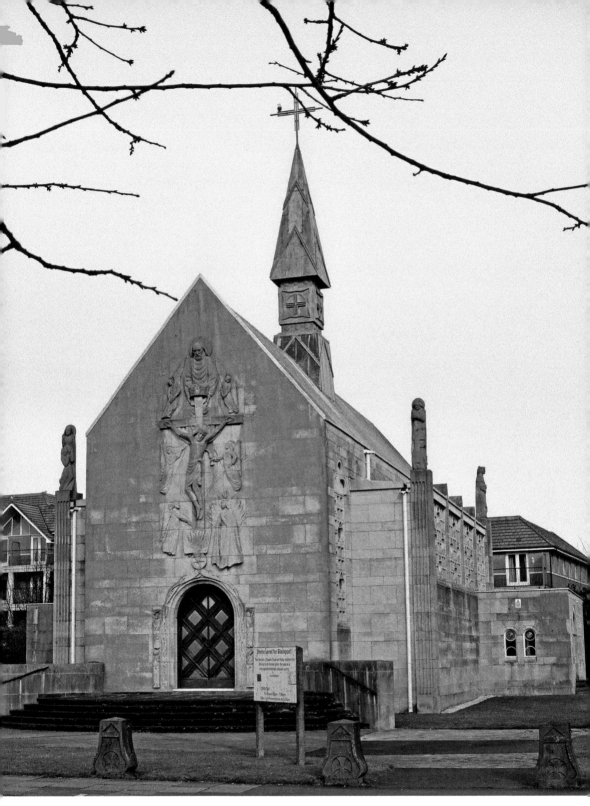

Shrine of Our Lady of Lourdes.

South Shore Open Air Baths

South Shore Open Air Baths opened on 9 June 1923 to a design by J. C. Robinson, in a faience-clad classic 'Colosseum' style. It was said to be the largest open-air baths in the world and hosted the final swimming and diving trials for the 1928 Olympics in Amsterdam. It also hosted the Miss Blackpool and Miss United Kingdom beauty contests for many years. It closed in the early 1980s and was demolished in early 1983. The Sandcastle indoor leisure centre was built on the site and opened in 1986.

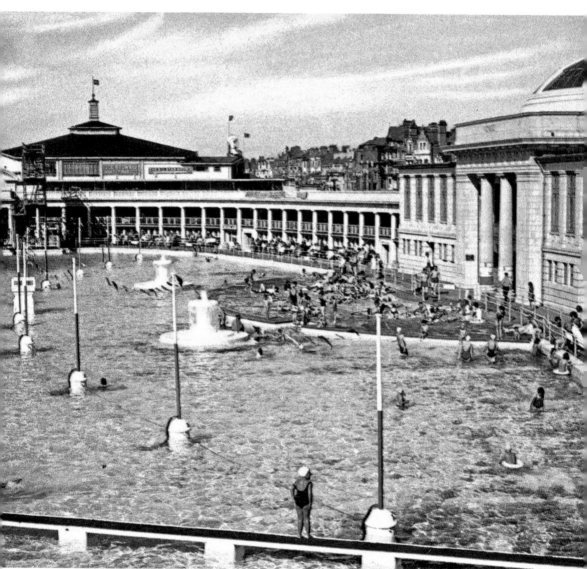

South Shore Open Air Baths.

Speedway

In the late 1920s Blackpool had two speedway or 'dirt-track racing' venues, one at the Highfield Road Sports Ground, South Shore, where meetings were held between 1928 and 1930 and another at South Shore Greyhound Stadium on St Anne's Road between 1928 and 1929. The first meeting was held at the Highfield Road Sports Ground on 21 April 1928, in a joint promotion between North Manchester Motor Club and the Blackpool & Fylde Motor and Aero Club. Races were run around the half-mile oval track in a clockwise direction (opposite to the normal) and it is said that there were over 7,000 spectators at the first meeting. The land was sold to Blackpool Corporation in April 1931 for the building of Highfield School. The St Anne's Road Stadium speedway track was constructed inside the dog track. The first meeting, promoted by the British Dirt-Track Racing Association Ltd, was held at 2.30 p.m. on 11 September 1928 and some 2,000 people attended. The land was sold for housing around 1964 and Stadium Avenue now occupies the site. There were proposals for a speedway track at Blackpool Rugby League Stadium, at Princess Street, in the mid-1960s but this did not come to fruition.

St John's Church

The first church on the Church Street site was dedicated to John the Evangelist and consecrated on 6 July 1821. Before that All Hallows Church at Bispham was used for

St John's Church.

Blackpool's baptisms, marriages and burials. St John's became a parish in 1860 and the first church was demolished in 1877 in order to build a larger church to accommodate the growing congregation of the developing town. Dr W. H. Cocker, then mayor of Blackpool, laid the foundation stone and the new church was completed in 1878. It is now a Grade II-listed building and was extensively renovated between 2000 and 2006. It houses a community and conference centre together with a dedicated area for the homelessness charity Streetlife, who assist vulnerable young people in Blackpool.

Storms and Shipwrecks

The Fylde coast has seem the demise of many ships over the years and a memorial (see photograph) was erected in 2012 on the promenade, at the northern boundary of the town with Cleveleys in commemoration. In recent years (31 January 2008) the *Riverdance*, RORO ferry, ran aground on the beach at Anchorsholme and suffered structural damage and had to be scrapped on site. Before that, in August 1981, the *Holland XXIV* dredging platform, which was working on the extension and renewal of the Anchorsholme sewage outfall was beached. Perhaps the most well-known shipwreck off Blackpool's coast is that of Nelson's flagship, HMS *Foudroyant*, which, while on a fundraising voyage around the coast of Great Britain ran aground on 16 June 1897 opposite Cocker Square. Other shipwrecks include the the Pea Soup wreck of August 1779 when a ship laden with peas was wrecked at Blackpool, the *Sirene* (9 October 1892) and the *Abana* (22 December 1894).

Storms and shipwrecks.

Swift, Frank – Goalkeeper

Frank was born in Blackpool on 26 December 1913, his first club being Blackpool Gas Works where he worked. When playing for Fleetwood he was signed by First Division club Manchester City in 1932 on 10s a week wages and spent his whole career there. He played nineteen times for England in 1946–49, retired in 1949 and became a football correspondent. He died in the Munich Air Disaster on 6 February 1958 after reporting on Manchester United's European Cup game against Red Star Belgrade.

Symbol Biscuits (Burtons Biscuits Co.)

The Blackpool Biscuit Co. (later Bee Bee Biscuits) originated in 1922 and built a new biscuit factory at the Mansfield Road site in 1932, pioneering pre-packed biscuits. Bee Bee Biscuits was acquired by J. Lyons & Co. in 1938 from Lesme Ltd and incorporated Symbol Biscuits in 1944. Symbol Biscuits, with its elephant head logo, was famous for its Maryland Cookies, which it introduced in 1956. The biscuit factory changed its name to Lyons Biscuits Ltd in 1990 and is now owned by Burtons Foods Ltd.

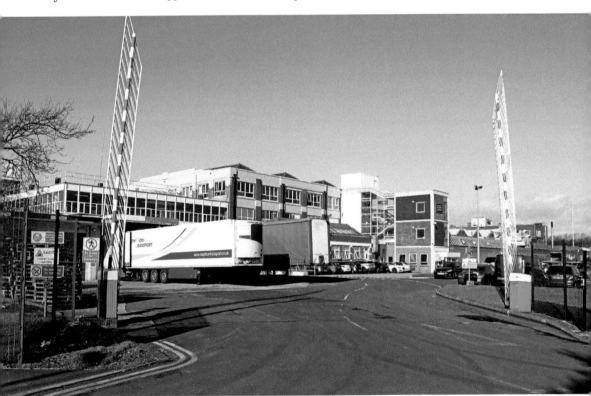

Symbol Biscuits.

T

Tower

Inspired by the Eiffel Tower (1889) and fuelled by the rapid development of Blackpool in the mid- to late 1800s, the Standard Contract and Debenture Corporation purchased the promenade site between Victoria Street and Heywood Street, where Sir Benjamin Heywood's house West Hey stood before being converted to the Prince of Wales Arcade (1867) and before Dr Cocker's Aquarium, Menagerie and Aviary buildings were added in 1873. The new Blackpool Tower Co. purchased the site in 1891, and if not for the determination of Alderman John Bickerstaffe, the building of Blackpool Tower would have failed due to lack of funding. However, John Bickerstaffe took control and increased his shareholding, thereby boosting confidence in the venture. The foundation stone was laid on 25 September 1891 and to help the funding, the fish, birds and animals were purchased from Dr Cocker's Aquarium and Menagerie and remained open to the public. The Tower was completed by the end of 1893, but the enveloping buildings were not fully completed when the Tower was opened on Whit Monday, 14 May 1894.

The Tower Circus is located at the base of the Tower between its four legs and originally advertised itself as 'The Tower Aquatic and Variety Circus'. It included animal acts with lions, elephants, cheeky chimpanzees, performing sea lions, polar bears on scooters, horses and dogs until 1990. The floor to the ring of the circus can be lowered and flooded with water for spectacular water finales. There have been several clowns at the Tower Circus over the years. The most well known are Doodles (William Lauder McAllister), who was the star clown between 1915 and 1944; Charlie Cairoli, with his trademark red nose and bowler hat, arguably the greatest clown to have appeared at the Tower Circus, appearing between 1939 until retiring in 1979; and the current resident star clown since 1999, Mooky (Laci Endresz Jnr), who was originally a juggler. Dancing at the Tower was originally in the Grand Pavilion but due to the lavishness of the Winter Gardens' Empress Ballroom (1896), John Bickerstaffe engaged Frank Matcham (the Grand Theatre architect) to create the sumptuous and world-famous Louis XV-style Tower Ballroom, which opened in 1899. The Tower Ballroom now features annually as an iconic and much-desired venue for the performers during the BBC's *Strictly Come Dancing*. Reginald Dixon MBE, whose signature tune was 'I do like to be beside the seaside', was the resident organist at the Tower Wurlitzer in the ballroom from March 1930 to March 1970. The menagerie (zoo)

Blackpool Tower.

closed in 1973 when Blackpool Zoo opened and the aquarium closed in 2010. The fish were moved to the nearby Sea Life Centre. The Tower continues to change and develop and has been magnificently lit with thousands of LED multicoloured lights. As well as the ballroom and circus, the building now includes the Blackpool Tower Eye, 4D cinema, 'walk of faith' glass floor at the 380-foot viewing platform, circus, Jungle Jim's children's play area and the Blackpool Tower Dungeon. Harry Ramsdens has taken over the Tower Lounge ground-floor space.

Talbot Road Bus Station

Talbot Road multistorey car park and bus station was the first true multistorey car park in the country. It was designed by G. W. Stead of Blackpool Council and built between 1937 and 1939 by Atherton Bros (Blackpool) Ltd. The ground floor was designed to take double-decker buses and the car park could accommodate 750 cars. The building has been redeveloped as part of the Talbot Gateway project and the large open ground-floor area that was the bus station is now occupied by commercial units, currently The Gym (part of a national chain) and Mr Basrai's Restaurant. The photograph shows the bus station in the late 1980s.

Talbot Road bus station.

Talbot Hotel and Waterloo Hotel – Bowling

The Talbot Hotel was built by Thomas Clifton in 1845 on the corner of Talbot Road and Topping Street in the year before Talbot Road station opened (29 April 1846). In September each year, from 1873, the Talbot held an annual crown green bowling handicap tournament on the bowling green at the rear of the pub, known as the 'Derby' of the bowling world. The Talbot Hotel was demolished in 1968 and the Prudential building built. The Talbot Trophy competition is now played at Raikes Hall. Today the UK's premier crown green bowling competition is the Waterloo Handicap, first played in 1907 at the Waterloo Hotel. In 1907 there 320 entries and the total prize money was £25. The winner was Jas Rothwell from West Leigh. Over the years the event has been regularly televised and the Waterloo Hotel, with its stands, is the only crown green bowling stadium in the country.

Talbot Road Gateway

Blackpool Council in partnership with Muse Developments delivered the first phase of the Talbot Gateway in 2014. The first phase includes the new council building at No. 1 Bickerstaffe Square, a new Sainsbury's store and the refurbishment of the building housing Talbot Road car park.

Talbot Road Gateway.

Taylor Woodrow

Frank Taylor was born on 7 January 1905 in Hadfield, Derbyshire, and moved to Blackpool with his family when he was thirteen. In 1921, aged sixteen, Frank persuaded the manager of the District Bank in Blackpool to lend him £400 to build two semi-detached houses in Central Drive. After they were built he paid back the loan and made a profit. As Frank was under age to buy land he formed a partnership with his Uncle Jack Woodrow (died 1929) and formed the Taylor Woodrow company. Frank moved to London in 1930, and Taylor Woodrow grew to become one of the largest construction companies in Britain. It merged with George Wimpey to create Taylor Wimpey on 3 July 2007 and is now the civil engineering division of VINCI Construction UK.

Thornber, Revd William

Blackpool's first historian was born on 5 December 1803 in Breck Road, Poulton, and educated at Baines Free School, Poulton, and later Trinity College, Oxford. After his ordination, William came to Blackpool in 1828 and assisted at St John's Church. He became the third curate on 3 January 1829 and subsequently married Alice Banks, the daughter of Henry Banks, on 13 December 1831. He published the first significant history of Blackpool in 1837 but was suspended from office due to drunkenness in 1843, and resigned in 1845. He owned the Beach Hotel (north corner of the Tower site) and is said to have indulged in bare-fist boxing. He died in a mental hospital in Stafford on 7 December 1885 and his body was returned to Blackpool and is interred to the east of St. John's Church.

Trams

The first electric tramway system in Britain was run by the Blackpool Electric Tramway Co. along the Promenade from near Cocker Square to Dean Street, South Shore, (officially) from 29 September 1885. The system used was the 'conduit system' where the cars took their power from a live electric rail in the centre channel between the tracks. When the lease expired in 1892, Blackpool Corporation took over the tramway. In 1895 they added a line along Lytham Road from Manchester Square to South Shore and in 1897 a line along Station Road, connecting Lytham Road to the Promenade. Originally there were eight open-topped double-decker trams and two trailers. Original tram No. 4 is on display at the National Tramway Museum at Crich. The conduit system was not reliable in its Promenade location and the system was converted to overhead lines by the Corporation in 1898. It was at that time that Dreadnought trams with their staircases at either end were introduced into service. When the Promenade widening from North Pier to South Pier was completed in 1905, the tramway was relocated away from the road into the promenade and the line was also extended north to Gynn Square. The Marton route opened in 1901 between Talbot

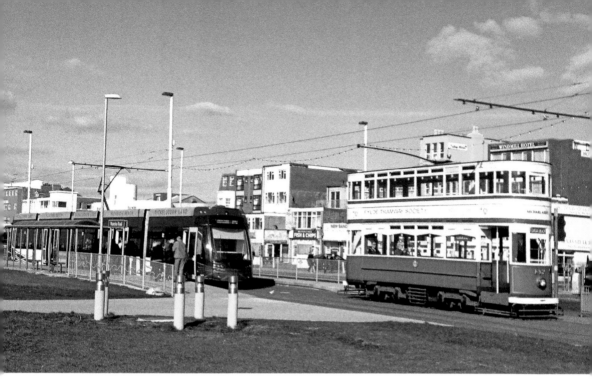

Trams.

Square, Abingdon Street, Church Street, Whitegate Drive and Waterloo Road, joining to the Lytham Road Route at Royal Oak. A new route was built along Central Drive, linking to the Promenade at the Tower and also linking to the Marton route. Another route was built from Talbot Square to Layton in 1902 and the Lytham Road route was extended to Squires Gate.

In 1920, Blackpool Corporation took over the 13-km route to Fleetwood when the Blackpool and Fleetwood Tramroad Co.'s lease expired and the Corporation immediately joined both systems at Gynn Square. Also the original Blundell Street Depot was replaced by the larger Rigby Road depot in 1920. In the late 1920s, the tramline was extended southwards past the Pleasure Beach, along the South Promenade to Starr Gate and also connected the Promenade line to the St Annes tramway. In 1936, the Central Drive and Layton routes were closed and the Lytham Road route closed in 1961. The Marton route closed in 1962 and the Dickson Road line from North station to the Gynn closed in 1963, leaving only the Promenade line from Starr Gate to Fleetwood, which remains today. Between 1962 and 1992 Blackpool was the only town in the UK that retained its trams until the opening of the Metrolink in Manchester. In November 2007 the tramway closed for five months to allow essential repair work to be carried out. Work to the remainder of the track (and new tram depot at Starr Gate) commenced in November 2009 and the last day the 'traditional' trams ran was 6 November 2011. The upgraded tramway reopened on 4 April 2012 with Flexity 2 cars providing day-to-day services. Works are now underway on the new tramway from the Promenade, at North Pier, along Talbot Road, terminating just before North station on the site of Wilkinson's store, which is to be demolished and a new hotel, shops and tram hub built.

Trinity Hospice, Bispham.

Trinity Hospice, Bispham

Trinity Hospice on Low Moor Road, Bispham, opened in 1985 and the complex includes Brian House Children's Hospice, which was purpose built in 1996. The dedicated staff at Trinity offer a high standard of care and compassion to patients from Blackpool and the Fylde coast. Trinity Hospice is a registered charity and is not part of the NHS. It currently (2018) costs over £7 million each year to fund the entire service with over £5 million a year raised by the local community and a further £2.5 million a year received from the local Primary Care Trust.

Town Hall

Blackpool's first Town Hall stood on the corner of Market Street at the south-west corner of the present Town Hall and was demolished in 1895. The new Town Hall was completed in 1900 and had a 180-foot-high spire, topped by a golden ship weather vane. The spire was removed in 1966 on safety grounds. It is a Grade II-listed building.

Town Hall.

Tunnels

There are many myths about tunnels in (under) Blackpool, few of which are true. The most well-known myth is the tunnel between the Tower and the Winter Gardens – presumably under Victoria Street. Other myths include tunnels connected to Raikes Hall, a tunnel between The Railway Hotel and North station, when it fronted onto Dickson Road, another from the Merrie England bar heading east up Talbot Road and another that there was (and still is) a tunnel between the Duke of York pub (corner of Dickson Road and Banks Street) and Unitarian Church (1873–1975) on the opposite (Bank's Street) corner. It is correct there is (was) a tunnel between the Tower and the adjacent Palace Theatre (later the site of Lewis'), which was constructed in 1914. It is now understood to be a storage area. Keith Roberts tells us there is a tunnel between the Gynn (toilets) and the toilets at Uncle Tom's Cabin lifts. The only other known tunnel in the town is the closed tunnel under the railway line on the west side of Devonshire Road Bridge, which was closed up when the bridge was constructed in the 1930s. Blackpool has miles of tunnels in the form of large diameter sewers, which were constructed in the 1960s using compressed air. Trials carried out at the time in the tunnels resulted in the 'Blackpool Tables', still used as the base for calculating the safe oxygen decompression times for diving works in the UK and internationally.

TVR

TVR was born out of the general engineering business started by Trevor Wilkinson (14 May 1923–6 June 1980) in 1946 in Beverley Grove, Blackpool. Trevor's business was originally named Trevcar Motors and was changed to TVR Engineering in 1947 when Jack Pickard joined the company. They built their first 'one-off' car in 1949, leading to several models of exclusive sports car including the Jomar, Grantura, Griffith, Tuscan, Vixen, 2500M and 350i, to name a few. The factory moved to Hoo Hill, Layton, in the 1960s and to Bristol Avenue from late December 1970 to 2006. A new TVR Griffith model is planned to be built at a new factory in Ebbw Vale from 2018. The photograph shows the 390SE Vee 8, 3900cc model.

TVR.

Uncle Tom's Cabin

Uncle Tom's Cabin was on the edge of the cliffs approximately opposite the end of Shaftesbury Avenue. It was originally the site of a refreshment stall run by Margaret Parkinson in the 1850s and opened on Sundays selling sweetmeats, gingerbreads, nuts and ginger beer to visitors walking along the clifftops. The stall was replaced by a hut and given the name 'Uncle Tom's', which is thought to refer to Margaret's brother-in-law, farmer Thomas Parkinson. The 'hut' was taken over by Robert Taylor and his partner William Parker in 1858 for £5 and a rental of £7 per annum. They extended the premises adding a bar parlour, three sitting rooms, bedrooms, a photographic studio and a camera obscura and advertised their Refreshment Rooms, known as Uncle Tom's Cabin, in the Fleetwood Chronicle of 1860. Licences to sell beer and spirits were later obtained and the premises extended to cater for concerts and dancing. The Taylor/Parker partnership ended in 1875 and in 1882 William Parker gave up proprietorship of the Cabin. The Gynn to Fleetwood tramway opened in 1898, with the Cabin being a favourite stopping off point. Continuing erosion to the cliffs made the premises unsafe and after part of the building collapsed into the sea, the Cabin was closed by

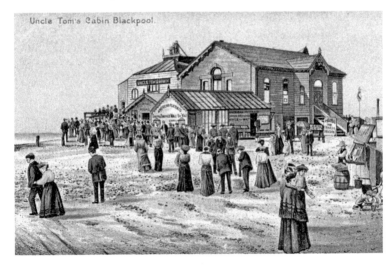

Uncle Tom's Cabin.

George Ashworth at 11.00 p.m. on Friday 4 October 1907 and the licence transferred to the new hotel across the road. The old buildings were demolished by 12 January 1908.

Uncle Peter Webster

'Uncle' Peter (Antony) Webster hosted twice daily children's shows and talent competitions at the open-air theatre on Central Pier from 1951 and played to packed audiences in the open air and the theatre. He retired in 1982 after some 5,000 shows and died at home on Sunday 22 May 2011.

UCP, Church Street

United Cattle Products (UCP) was a company formed in Manchester in 1920 by fifteen Lancashire tripe dressers. Tripe, like black pudding, cowheels and offal, were hugely popular in the industrial north and there were several UCP shops/restaurants in Blackpool including the Derby restaurant and snack bar, shown in the picture, on the corner of Church Street and Corporation Street, opposite the entrance to the Grand Theatre. This shop closed in the early 1970s and the site was later a Clarks shoe shop and is now a Nando's restaurant. There was another in Bank Hey Street behind the Tower and another in the Strand near Prestons the jewellers, as well as a tripe shop on Topping Street.

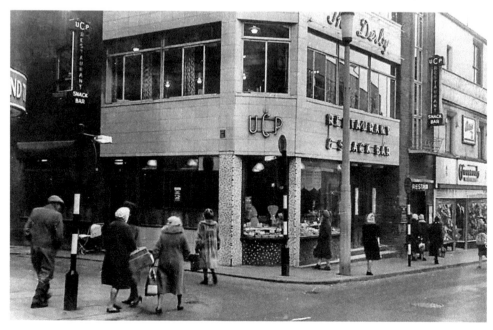

UCP, Church Street.

Violet Carson OBE (Ena Sharples)

Violet Helen Carson was born in Ancoats, Manchester, on 1 September 1898. She played piano, sang soprano and was an actress. She married cricketer George Peploe in 1926, but he died in 1929, aged thirty-one, and she never remarried. She joined BBC Radio in Manchester in 1935 and is most well known for her portrayal of the battle-axe 'hairnetted' figure of Ena Sharples, in ITV's *Coronation Street* from its first episode on 9 December 1960 to 2 April 1980. She switched on the Illuminations in 1961 and was made an Officer of the Order of the British Empire in 1965. Violet lived in Blackpool from the late 1920s and lived in a bungalow on Fleetwood Road, Bispham. Violet died, at home, on Boxing Day 1983, age eighty-five.

Violet Carson OBE (Ena Sharples).

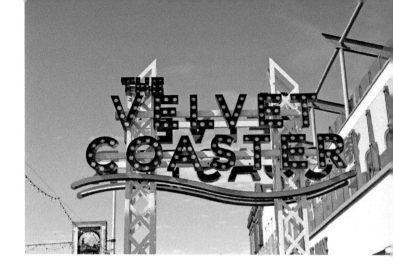

Velvet Coaster.

Velvet Coaster Ride and Pub

The Velvet Coaster (1909–32) at Blackpool Pleasure Beach was a wooden roller coaster ride, designed by William Strickler, with an oval-shaped circuit. Wetherspoon's Velvet Coaster pub on the Promenade opened in May 2015 on the site of what had been the Lucky Star amusement arcade, made famous in the 2004 BBC comedy musical *Blackpool* starring David Morrissey and David Tennant.

Victoria Hospital

Victoria Hospital was originally located on Whitegate Lane (Drive) where the new health centre is now located and was named after Queen Victoria. It opened on 25 August 1894 with four wards capable of holding twelve beds and three cots. The first matron was Miss A. Peel. The foundation stone of the new hospital at Whinney Heys was laid by Lord Derby on 9 June 1933 and it opened in 1937. Miss Elsie Maclean was the matron from 1935 until retirement in 1957. It is now the main hospital for Blackpool and the Fylde coast and is part of the Blackpool Teaching Hospitals NHS Foundation Trust.

Victoria Hospital.

Winter Gardens

The development in the mid- to late 1800s of the winter garden (conservatory) concept into large, publicly accessible buildings in seaside towns, where visitors could enjoy a variety of entertainment facilities all-year round and away from inclement weather, led to the establishment of the Winter Gardens Co. in 1875 and the official opening of the Winter Gardens on 11 July 1878. The Winter Gardens was built on the 6-acre Bank Hey estate of Dr W. H. Cocker. Gardens and an open-air roller skating rink first opened on 27 July 1876, while the foundations to the main building were being constructed and an indoor skating rink was completed in 1877. The Church Street entrance, its 120-feet-high circular glass dome, the Grand Pavilion, Vestibule and the elegant Floral Hall, with its curved glass and steel roof, statues, flowering plants, exotic palms and tree ferns opened in 1878. The first Her Majesty's Opera House, designed by Frank Matcham, opened on 10 June 1889 and was replaced in 1911. The façade was extended in the same style in 1939 with the construction of the present Opera House, the third on the site, which opened on 14 July 1939. Electric lighting to the whole building was installed in 1893 and the 220 foot Great Wheel opened in 1896. The Empress Ballroom and the Indian Lounge both date from 1896/97 and the glass arched Winter Gardens Coronation Street entrance was completed in 1897. The arch and Coronation Street elevation was clad in white faience in 1930 when the Olympia was built. The Spanish Hall was opened in 1931 after the Winter Gardens had been acquired by the Tower Co. on 9 February 1928. A mezzanine floor was created in the Coronation Street Palm House area and an unusual and inspired Spanish Hall with Andalusian village representations in the corners was created by art director Andrew Mazzei. The Winter Gardens has hosted the annual conferences for all of the main British political parties and has been the home of the Blackpool Dance Festival since 1920. EMI took over the Tower Co. (and the Winter Gardens) in 1967 and First Leisure took over in 1983. The Winter Gardens were purchased by Blackpool Council from Leisure Parcs Ltd in 2010 and continues to thrive.

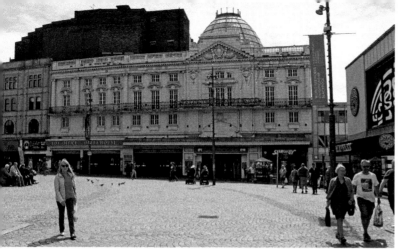
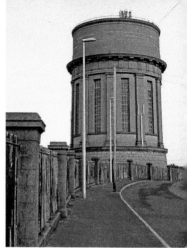

Above Left: Winter Gardens. Above *Right*: Water Tower, Leys Road.

Water Tower, Leys Road

The Water Tower on Leys Road, Warbreck, was built in 1931–32, for what was then the Fylde Water Board – now United Utilities. The tank (at 37.5 metres above ground level) receives water by pumps from the adjacent Devonshire Road service reservoir, which is fed from Barnacre Reservoir at Longridge, Preston. The tank holds some 114,000 cubic metres of water and maintains the pressure for water supplies to the houses of central and northern Blackpool.

Windmills (Little Marton, Great Marton and Hoo Hill)

In the eighteenth and nineteenth centuries, the Blackpool and the Fylde area had some forty windmills and watermills. Now the only windmill in Blackpool, as seen in the photograph, is Little Marton Mill, adjacent the A583 Preston New Road at Mereside. Little Marton Windmill was built in 1838 and worked until 1928. It was given to the Allen Clarke Memorial Fund in 1937 by Cornelius Bagot and is a Grade II-listed building. Allen Clarke was a writer and windmill enthusiast (also known as Teddy Ashton) and he published *Windmill Land* in 1916. The mill was renovated in 1987 at a cost of £88,000. Great Marton Windmill, at Marton Green (Oxford Square), dates from around 1775. A hostelry near to the windmill opened in the 1840s, known as the Mill Inn, later The Oxford. The site has been occupied since November 2015 by a new Aldi supermarket. A wooden 'peg mill' existed at Hoo Hill in Layton in the sixteenth century. The last mill on the west side of Westcliffe Drive (near Nos 114–116 Mansfield Road), erected in 1736, was made of brick from a croft near the present Metropole Hotel. It had five storeys beneath its dome, which was positioned by rope and wheel, so it was often called 'Wheelmill'. John Gratrix was the last miller, and the mill was badly damaged in a violent storm at the end of July 1881.

Little Marton Windmill.

It was demolished in the mid-1890s. An 'Illuminations' Windmill, with a weather vane and two brass cannons, stood on top of the pumping station and toilets on the Promenade at Manchester Square from 1931 and was moved to a site opposite the end of Waterloo Road when the new Headlands coast protection works were carried out in the early 2000s. It was later moved to Rigby Road for repairs but has not returned to the Promenade.

Woolworths

Woolworths' flagship, art deco-style superstore, on the Promenade just south of the Tower, opened in 1937 on the site of the Royal Hotel and the small Woolworth's Bazaar. The ground floor and basement housed Woolworths, while a large cafeteria was on the first floor with an overflow café on the second floor and its own bakery on the roof. It closed in 1985 and was run as Pricebusters until 2008. The Albert and The Lion (Wetherspoon) pub together with Peacocks (fashion) occupies the front ground-floor space and Sports Direct. com occupy part of the first floor.

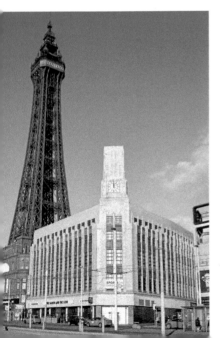

Woolworths.

Wrestling in Blackpool

All-in professional wrestling, with its showmanship, became popular in Britain in the 1930s. It appeared on the television in 1955 and became a major attraction when it was featured every Saturday afternoon from 1964 to 1985 on ITV's *World of Sport*, with Ken Walton as commentator. Wrestling in Blackpool was a regular event with shows hosted at the Tower Circus ring, Central and South Piers and at the Horseshoe Showbar, Pleasure Beach. The best-known wrestlers of that time were Big Daddy, Giant Haystacks, Kendo Nagasaki and Mick McManus. Famous 'local' wrestlers included (Dirty) Jack Pye (the Doncaster Panther, died 8 December 1985), Tony Francis (the Blackpool Rock, died 22 May 2017), and Steve Regal (Darren Matthews), who first made a name for himself aged fifteen while wrestling at the Horseshoe Showbar at Blackpool Pleasure Beach. On Saturday 14 January 2017, Blackpool hosted the first ever WWE UK Championship tournament at the Empress Ballroom.

Tower Circus wrestling.

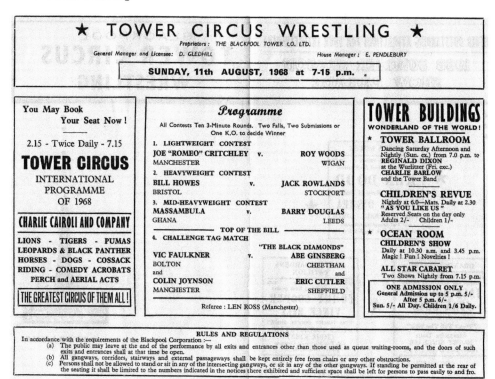

★ TOWER CIRCUS WRESTLING ★

Proprietors: THE BLACKPOOL TOWER CO. LTD.

General Manager and Licensee: D. GLEDHILL House Manager: E. PENDLEBURY

SUNDAY, 11th AUGUST, 1968 at 7-15 p.m.

You May Book Your Seat Now!

2.15 - Twice Daily - 7.15

TOWER CIRCUS

INTERNATIONAL PROGRAMME OF 1968

CHARLIE CAIROLI AND COMPANY

LIONS - TIGERS - PUMAS LEOPARDS & BLACK PANTHER HORSES - DOGS - COSSACK RIDING - COMEDY ACROBATS PERCH and AERIAL ACTS

THE GREATEST CIRCUS OF THEM ALL!

Programme

All Contests Ten 3-Minute Rounds. Two Falls, Two Submissions or One K.O. to decide Winner

1. LIGHTWEIGHT CONTEST
JOE "ROMEO" CRITCHLEY v. ROY WOODS
MANCHESTER WIGAN

2. HEAVYWEIGHT CONTEST
BILL HOWES v. JACK ROWLANDS
BRISTOL STOCKPORT

3. MID-HEAVYWEIGHT CONTEST
MASSAMBULA v. BARRY DOUGLAS
GHANA LEEDS

——————— TOP OF THE BILL ———————

4. CHALLENGE TAG MATCH
"THE BLACK DIAMONDS"
VIC FAULKNER v. ABE GINSBERG
BOLTON CHEETHAM
and and
COLIN JOYNSON ERIC CUTLER
MANCHESTER SHEFFIELD

Referee : LEN ROSS (Manchester)

TOWER BUILDINGS

WONDERLAND OF THE WORLD!

★ **TOWER BALLROOM**
Dancing Saturday Afternoon and Nightly (Sun. ex.) from 7.0 p.m. to **REGINALD DIXON** at the Wurlitzer (Fri. exc.) **CHARLIE BARLOW** and the Tower Band

CHILDREN'S REVUE
Nightly at 6.0—Mats. Daily at 2.30 " AS YOU LIKE US " Reserved Seats on the day only Adults 2/- Children 1/-

★ **OCEAN ROOM**
CHILDREN'S SHOW
Daily at 10.30 a.m. and 3.45 p.m. Magic ! Fun ! Novelties !

ALL STAR CABARET
Two Shows Nightly from 7.15 p.m.

ONE ADMISSION ONLY
General Admission up to 5 p.m. 5/- After 5 p.m. 6/- Sun. 5/- All Day. Children 1/6 Daily.

RULES AND REGULATIONS

In accordance with the requirements of the Blackpool Corporation :—
(a) The public may leave at the end of the performance by all exits and entrances other than those used as queue waiting-rooms, and the doors of such exits and entrances shall at that time be open.
(b) All gangways, corridors, stairways and external passageways shall be kept entirely free from chairs or any other obstructions.
(c) Persons shall not be allowed to stand or sit in any of the intersecting gangways, or sit in any of the other gangways. If standing be permitted at the rear of the seating it shall be limited to the numbers indicated in the notices there exhibited and sufficient space shall be left for persons to pass easily to and fro.

XL Ales – Catterall & Swarbrick Brewery Ltd, Talbot Road

XL Ales was Catterall & Swarbrick Brewery Ltd's most well-known beer and was brewed and bottled at its brewery on Talbot Road, on the corner of Abattoir Road (now Coopers Way), built in 1927. The strength of beer at that time was often characterised by the number of 'Xs' an ale was designated and it is thought that 'XL', being the Roman numerals for forty, depicts an ABV of 4.0 per cent. C&S was taken over by Bass Charrington in the 1960s

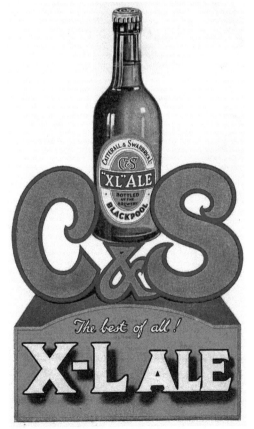

XL Ales – Catterall & Swarbrick Brewery Ltd, Talbot Road.

and brewing stopped in 1974. The brewery was demolished in 2000 and the site has been redeveloped for housing with new road names such as Catterall Close and Swarbrick Close.

X-Rated Shows – 'Sideshows' on the Promenade

Blackpool has a long history of Promenade sideshows. Those promoted by the brilliant Luke Gannon during the 1930s in premises on the corner of Brunswick Street, now the site of the modern Pyramid Plaza Shopping Centre, are the most controversial. Gannon had starving bride shows, where allegedly recently married couples starved for thirty days in glass cabinets, to be stared at by passers-by who paid tuppence for the privilege. It was claimed the newly-weds would receive £250 if they completed their fast. Gannon also exhibited the discredited former vicar of Stiffkey in Norfolk, who had been defrocked following allegations that he consorted with women of ill repute. The former vicar sat in a barrel and peered through a hole to meet visitors and presumably receive a share of the takings. Later Gannon exhibited the self-styled Colonel Barker, who had been born a woman, to 1930s visitors confused by the gender identity issue. Visitors who passed down a corridor could peer into a basement room and see the Colonel and his wife on two beds, with a Belisha beacon and traffic lights set on red between the beds. The same premises were used in the 1950s by another promoter for a sideshow that was claimed to deter young people from taking drugs. Further up the Promenade the Montmartre Theatre had semi-naked 'girlie' shows in the '50s and '60s, legal if the girls remained perfectly still as this would equate to art rather than pornography.

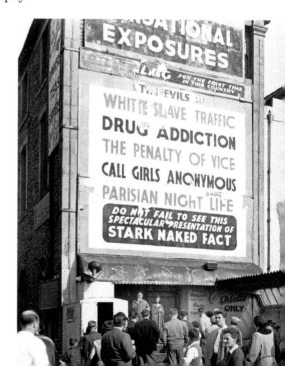

Chards, Golden Mile, c. 1955.

Yates's Wine Lodge and Tivoli Cinema

Yates's Talbot Square premises opened in July 1896 on the ground floor of what was originally the Theatre Royal (1868) and later (1880) the Blackpool Free Public Library and Reading Rooms. It had a long snake-like bar serving sherry and port, there were hogsheads of Australian white and red wine and a separate champagne stall serving champagne on draught at ten (old) pence a glass (about 4p). Yates Bros Ltd converted the upper floor (the Theatre Royal) into the Tivoli Cinema in around 1909 and the interior of the Tivoli was reconstructed in 1930, when it was equipped for sound films. The cinema was destroyed by fire in October 1964 but the Wine Lodge beneath survived and the cinema itself was refurbished and reopened in April 1965. In the 1970s it was the Talbot Bingo Club but closed in September 1980. It reopened again for a short period in 1982 as the Tivoli Cinema. By 1991 it had become the Music Hall Tavern and later it was converted into Addisons nightclub. Yates's Wine Lodge suffered a fire on 15 February 2009 destroying the building, which was subsequently demolished. Yates's was not a listed building and one of Blackpool's most prestigious sites remains undeveloped at the date of publication of this book.

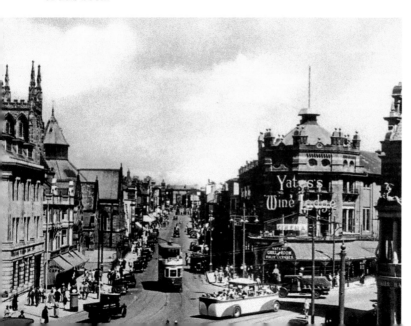

Yates's Wine Lodge.

Yeadon Way.

Yeadon Way

Yeadon Way, which connects the M55 with the town centre, is named after Harry Yeadon (1922–2015), civil engineer and former county surveyor and bridgemaster of Lancashire. The railway line on the embankment through Marton originally opened in 1903 as the Marton Line between Kirkham North Junction and Blackpool South (at Waterloo Road) and was an express railway line. It closed in 1965 after the closure of Central station. After the M55 opened in July 1975, the Central Railway Route, subsequently renamed Yeadon Way, was constructed and opened to traffic in January 1986. It was closed for major repairs in late 2014/early 2015.

Yeomanry, No. 221 Talbot Road

The Blackpool troop ('D' Squadron) of the Duke of Lancaster's Own Imperial Yeomanry was raised in 1899 by Captain (later Major) T. A. Shepherd-Cross. Prior to the formal opening of the new headquarters and Drill Hall on New Road (Talbot Road) on 17 July 1903, dismounted drill took place in the Old Ballroom at Raikes Hall. The new building with its Accrington brick frontage and battlement coping comprised a residence for the Sgt-Major Instructor, armoury, Officer's House and a 90 by 40-foot Drill Hall with asphalt floor. The Drill Hall closed in 1992.

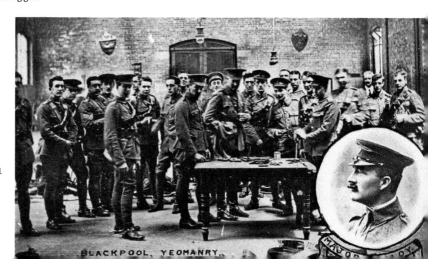

Yeomanry, No. 221 Talbot Road.

Zoo

The land off East Park Drive on which Blackpool Zoo stands was farmland until it became Stanley Park Aerodrome in 1929 and officially opened in 1931. When the Second World War was declared on 1 September 1939, the aerodrome was requisitioned as an RAF technical training centre and is thought to have closed in the early 1950s. It later became home for the Royal Lancashire Show until 1970. The zoo at Blackpool Tower closed in 1970 and Blackpool Zoo opened on Thursday 6 July 1972, with 3,543 people attending the launch. In 2014 the Ape House, built in the 1970s, was extended and Orangutan Outlook opened to house the zoo's family of orangutans. The zoo continues to be developed and a new elephant house and paddock was opened in 2017 when Project Elephant was completed. The zoo celebrated its 15 millionth visitor in April 2017 and is now owned by Parques Reunidos, a Spanish-based leisure organisation. Gina, the Californian sea lion, and Charlie, her trainer, are seen in the picture.

Gina the sea lion and Charlie, Blackpool Zoo.

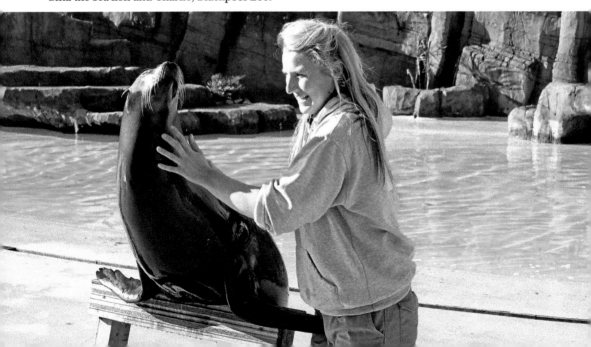

Zip wires.

Zip Wires

In the early 1900s a small-scale zip wire (the Aerial Flight ride) was constructed on the beach adjacent to the developing Pleasure Beach. The 1905 postcard seen here portrays an absence of any health and safety concerns. In 1994, the presenters of *Record Breakers*, Roy Castle and Cheryl Baker (with the help of the Army), abseiled down from the Tower top towards Central Pier, over the tram tracks, which were shut off. There were plans for a zip wire from Blackpool Tower to the beach in 2001 but it did not go ahead.

Zoë Ball

Zoë Louise Ball was born in Blackpool on 23 November 1970 but grew up in Buckinghamshire. She has presented numerous television and radio shows and was the first female host of the Radio 1 *Breakfast Show* in 1998. Between 1996 and 1999 she presented the children's show *Live & Kicking* and finished third in the 2005 (Series Three) *Strictly Come Dancing* show. Zoë now presents on Radio 2 and is the host of the BBC's *Big Family Cooking Showdown* and *Strictly – It Takes Two*.

Sources and Acknowledgements

Blackpool Local History Library, *Blackpool Gazette*, Chris Wood, Alexandra Winter, Antony Hill, Nick Moore, Tims, Norman Butler, Keith Roberts, Lister Streefkirk, Rob Posner, Scholastic Photo Co., Bispham Gala Committee, Mrs E. Gilbert, Mrs A. Gilbert, Martin Slack, Clare Wood, Norma Fowden, Linda Edgar, Dave Heaney, Barry Sidley, Dave Furber, Rachel Bottomley and Rebecca Bottomley.

The royalties from this book will be donated to Trinity Hospice, Bispham.

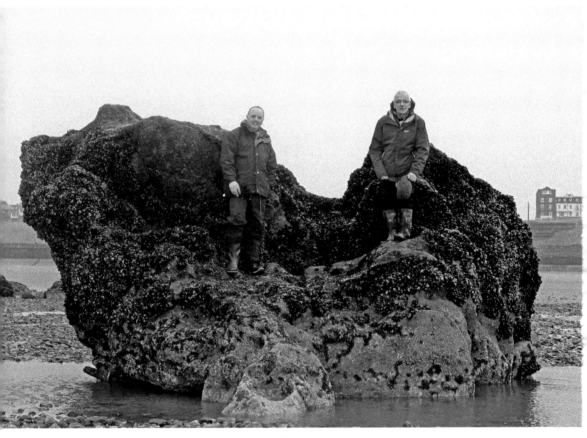

Authors Allan and Chris on Carlin Stone, March 2018.